LAUREL GLEN PUBLISHING

THE ART OF MEDIEVAL MANUSCRIPTS

KRYSTYNA WEINSTEIN

Published in the United States by Laurel Glen Publishing, 1997.

Laurel Glen Publishing
5880 Oberlin Drive, Suite 400, San Diego, CA 92121

First published in 1997 by Hamlyn, an imprint of Reed Consumer Books
Limited, Michelin House, 81 Fulham Road, London SW3 6RB and Auckland,
Melbourne, Singapore, and Toronto

ISBN 1-57145-632-5
Library of Congress Cataloging-In-Publication Data available upon request.

Printed and bound in China

Publishing Director: Laura Bamford
Executive Editor: Mike Evans
Editor: Humaira Husain
Art Director: Keith Martin
Senior Designer: Geoff Borin
Design: Richard Scott
Production Controller: Mark Walker
Picture Research: Charlotte Deane

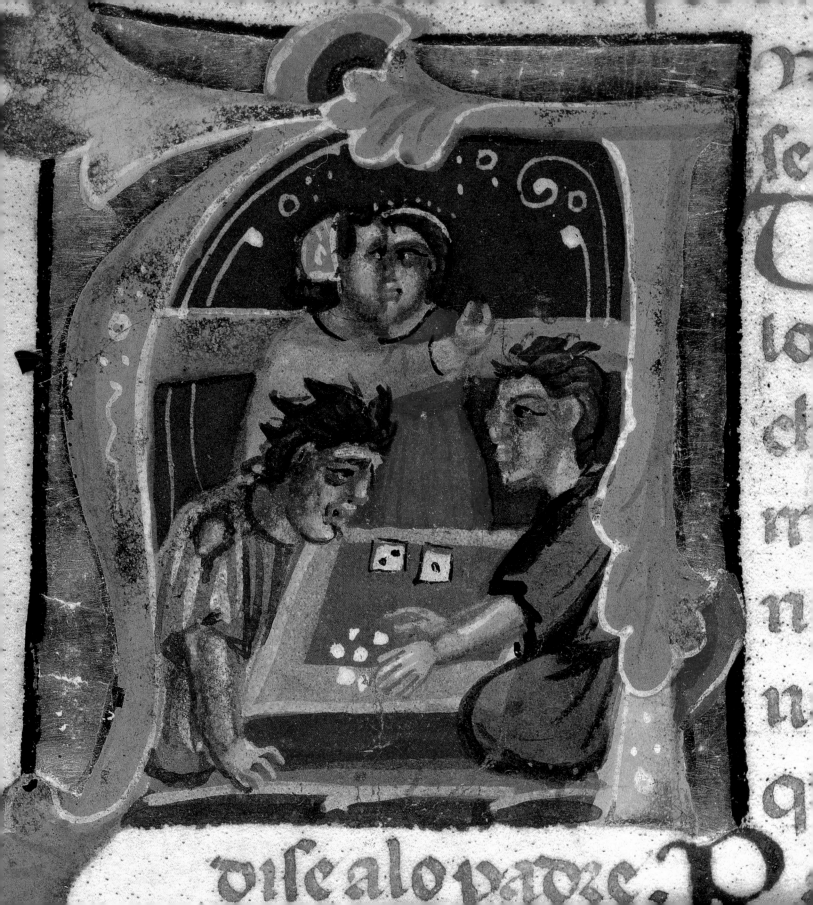

diſcalopaze. P

O f all the works of art that have survived from the Middle Ages, manuscripts are the most common. There are literally hundreds of thousands, many of them luxurious, many functional. Only some 5% of them are highly decorated, and these are the ones that we now so admire. They are the most vivid way of learning about the people of those times: their beliefs, customs, interests, and tastes. The appearance of manuscripts and their size varied considerably, depending on their function, and their owners' or patrons' interests and intentions. Visually, manuscripts of the 8th century bear little similarity to those of the 15th century.

FROM SCROLL TO CODEX

The book—or codex—began to replace the scroll as the main way of transmitting text and illustrations in Western Europe between the 1st and 3rd centuries AD. Scrolls were rolls of papyrus or parchment of up to 35 feet in length, with narrow columns of text, sometimes interspersed with simple illustrations. These scrolls were unrolled sideways.

The advantages of the codex were quickly recognized: pages of regular and similar sizes, with space for more text, and offering more opportunity for varied text and illustration layout; easier to find one's place in the text; no longer small illustrations, but large, full-page, even narratives spreading over several pages were possible. The parchment was better preserved within two boards (covers). And flat parchment which wasn't rolled allowed thicker pigments to be used, thereby improving the quality and durability of the illustrations.

Very few early codices survive, but during the 8th and 9th centuries many faithful copies of them were produced. The style of illustrations in them influenced subsequent illustrations throughout the medieval period, particularly in continental Europe. Naturalism (creating lifelike images) and illusionism (creating a 3-dimensional space on a 2-dimensional surface) are characteristic of this art.

The earliest scribes of Antique secular texts (who were probably also the artists) were frequently slaves or freedmen. Later it seems the same craftsmen worked on both secular and early Christian texts. By the 7th century monasteries had largely taken over the book production of ecclesiastic texts. Few secular texts were produced.

BYZANTINE INFLUENCE

Throughout the medieval period, another important influence on manuscript illumination was Byzantine art, with Constantinople as its artistic center. Italy had always had close contacts with Byzantium, and during the period of iconoclasm from 730-843, many artists fled and settled in southern Italy. By the 10th century, when art was again flourishing in Byzantium as well as Italy, renewed western contacts brought many examples of the art to the courts and monastic centers across Europe, especially during the 12th century.

Byzantine art had its roots in Late Antique art, but the elements of Byzantine art from which western artists primarily drew were the use of gold backgrounds in illuminations, the monumental figures, and the strongly modeled faces.

A 14th century English bas de page illustration from the Breviary of Marguerite de Bar.

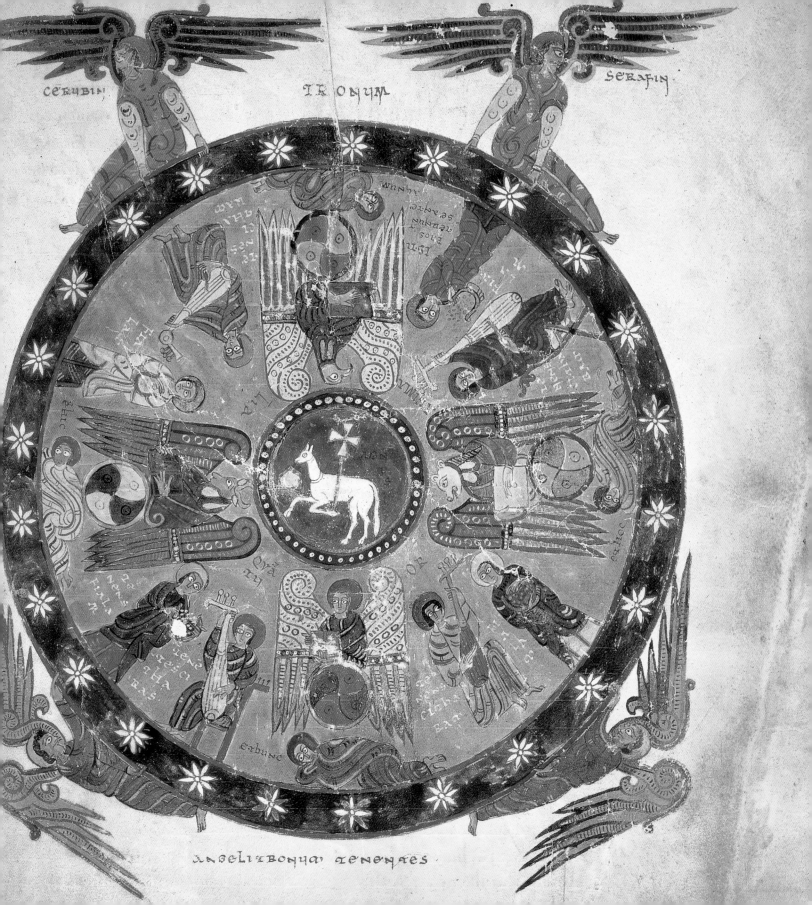

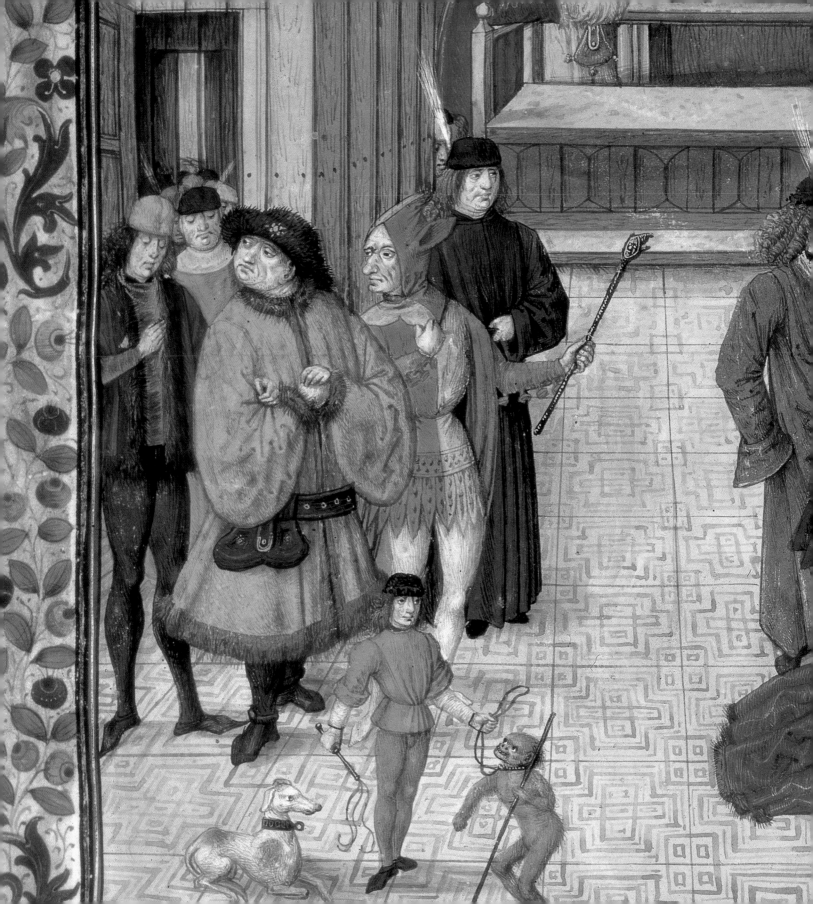

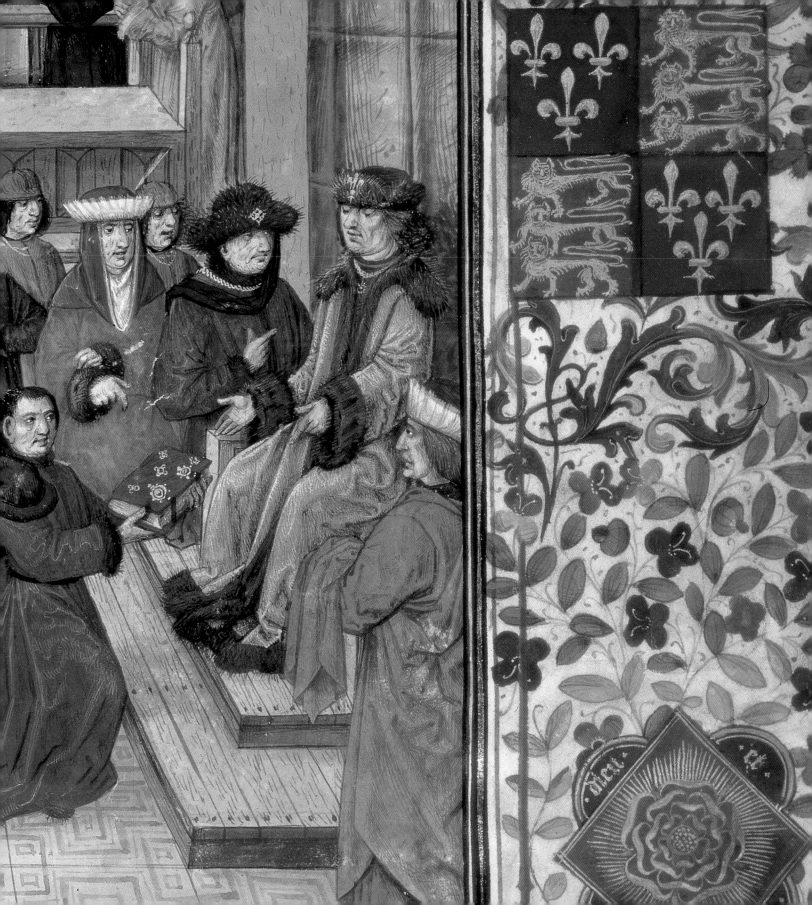

ALVSIBI
SITADÑOIS
SVXPOORC
GINAQVE
OMIBVSIN
hoasexv
POSITIS
PRESTASOLVS
ELIGANTIA

Ego seruus tuus nobilitati

tue digna facere mea

exhibere nequeo: quaq:

THE MIDDLE AGES WERE A VERY DEVOUT ERA; HENCE, THE MAJORITY OF ILLUMINATED MANUSCRIPTS WERE RELIGIOUS. HOWEVER, AS EDUCATION BECAME MORE WIDESPREAD, THERE GREW A THIRST FOR KNOWLEDGE WHICH RESULTED IN THE SECULAR BOOK TRADE EXPANDING, WITH A PUBLIC TASTE FOR ROMANCES, LITERARY TEXTS, AND HISTORIES DEVELOPING. THE FOUNDING OF THE UNIVERSITIES IN THE 13TH CENTURY LIKEWISE CREATED A NEED FOR STUDENT TEXTS. MANUSCRIPTS CREATED FOR PUBLIC USE, SUCH AS BIBLES, TENDED TO BE VERY LARGE. THOSE FOR PRIVATE USE, SUCH AS PSALTERS AND BOOKS OF HOURS, WERE SMALL. OWNERSHIP VARIED, FROM THE INSTITUTIONS SUCH AS MONASTERIES AND CATHEDRALS, TO THE PRIVATE OWNERS, SUCH AS ROYALTY, RICH NOBLES AND, BY THE 15TH CENTURY, RICH MERCHANTS. SECULAR MANUSCRIPTS WERE NOT AS LAVISHLY ILLUMINATED AS RELIGIOUS TEXTS, AND USUALLY WRITTEN IN THE VERNACULAR. AND IT IS MOST IMPORTANT TO REMEMBER THAT MOST MEDIEVAL BOOKS WERE "COPIES" OF PREVIOUS TEXTS.

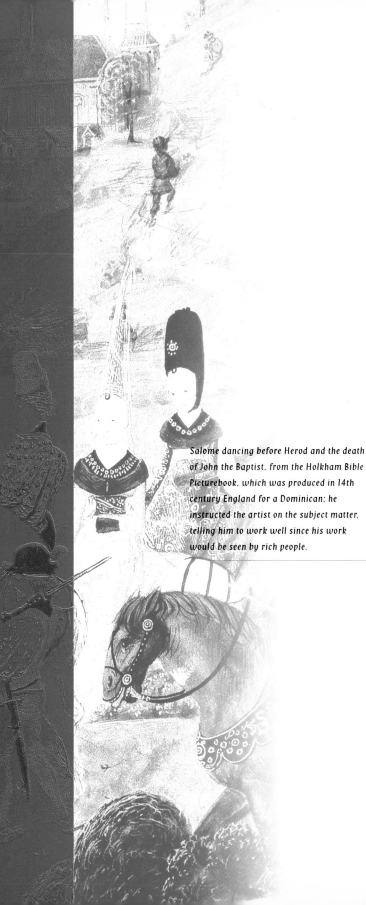

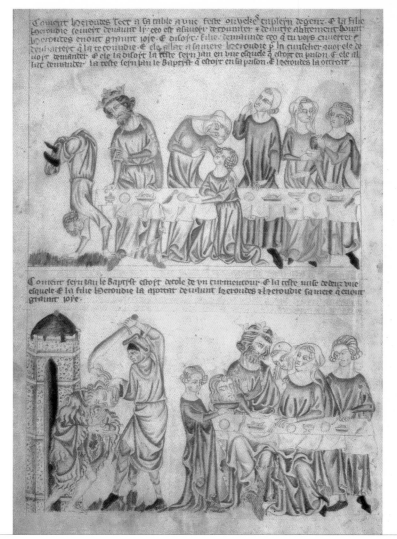

Salome dancing before Herod and the death of John the Baptist, from the Holkham Bible Picturebook, which was produced in 14th century England for a Dominican; he instructed the artist on the subject matter, telling him to work well since his work would be seen by rich people.

THE BIBLE

Bibles were among the largest books produced during the early Middle Ages, some measuring nearly 20 in. x 14 in., often in two or more volumes. These large Bibles were primarily intended for monasteries and religious institutions, to be read aloud from lecterns during services or at meal times, and to be studied. Smaller one-volume Bibles were produced in the 13th century, largely for study by the growing university student population, or for actual preaching purposes by the Franciscan and Dominican friars.

Latin gave way to vernacular versions of certain books of the Bible as early as the 10th century in Anglo-Saxon England, and elsewhere in the 13th and 14th centuries.

PSALTERS

Psalters consisted primarily of the 150 psalms. They were usually devotional or study books, and the most popular lay person's book before the books of hours in the late 13th century. Traditionally the psalms were preceded by calendar pages, illustrated with the labors of the twelve months of the year, signs of the zodiac, and a list of saints' days, including those of importance to the patron or owner. They also contained other texts and prayers, chosen by the owner or person commissioning the book.

Psalters were used by lay persons privately or during the Divine Offices, and were one of a monk's and nun's basic texts to be sung or recited during the course of a week. They were also used for private devotion in homes, and by women in noble homes to teach children to read. We know, from a 13th century psalter, that King Louis IX of France learned as a child to read from it.

The main decoration normally occurs as a series of miniatures preceding the text, or as elaborate initials at the introduction to the main divisions between the psalms—1, 26, 38, 51, 52, 68, 80, 97, 101, and 109. The illustrations literally illustrated the text, or where the ideas expressed were abstract, a recognized set of images was used from the Old and New Testaments, varying from country to country.

An illumination from a mid-13th century psalter made for King Louis IX of France, which depicts Abraham and the three angels. The scene is set in typical Gothic cathedral architecture of the period with the huge rose windows.

BOOKS OF HOURS

Books of hours were best-sellers in the later Middle Ages, owned by royalty, nobles, and the rich alike, and could even, by the 15th century, be purchased in shops. Their popularity was due to a change in the Church's attitude to personal devotion in the 13th century, coupled with increasing literacy and an enormous growth in wealth during the 14th and 15th centuries. Many were small, pocket-sized, and easily portable.

Books of hours functioned as private prayer books, based on the eight canonical hours, or Divine Offices. The central text was the Hours of the Virgin, which had previously been appended to psalters. Recitation of these Hours was a lay person's attempt to follow the regular devotions of the religious. Books of hours contained other texts: a calendar (as in psalters); the penitential psalms; gospel extracts; and other prayers, some addressed to the Virgin, widely venerated in the Middle Ages.

Calendar pages in psalters and books of hours depicted agricultural labor through the year, and signs of the zodiac. This is from the December calendar page of the Bedford Book of Hours c.1423, showing the killing of a boar and the zodiac sign of Capricorn.

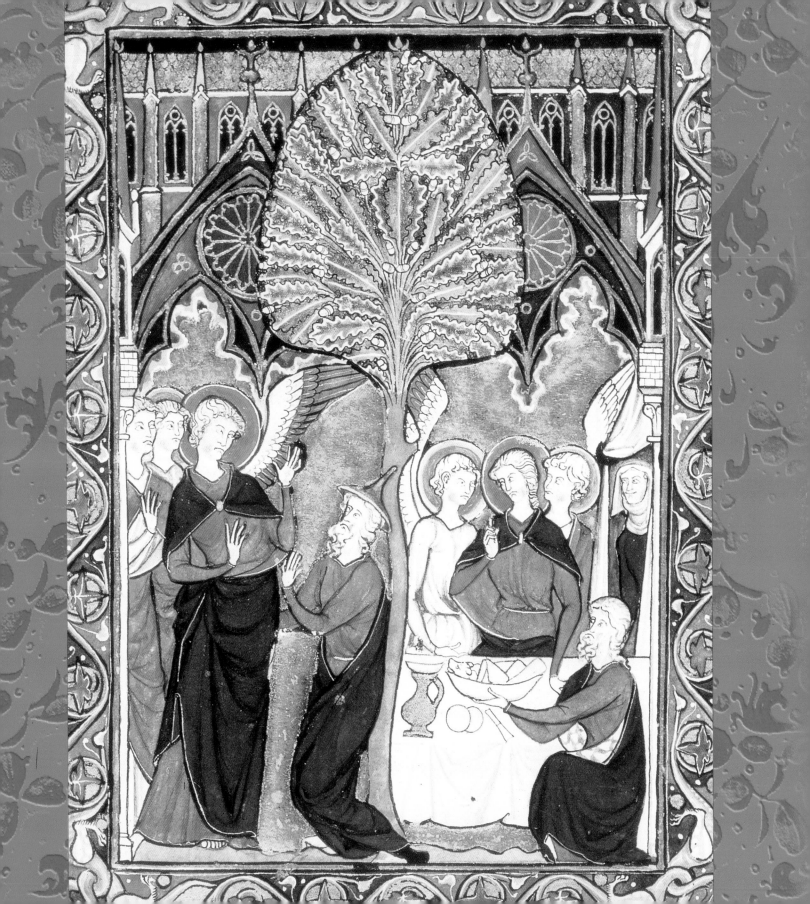

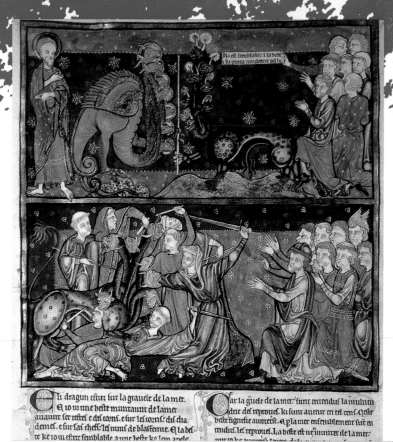

The 13th century English Trinity Apocalypse is a lavishly illuminated manuscript with a French text, describing here a seven-headed monster coming out of the earth.

An historiated initial "G" depicting the Adoration of the Magi, from a 15th century antiphonal, which was a type of choir book manuscript.

APOCALYPSES

The Apocalypse is the last book in the New Testament, also known as the Book of Revelations. The text of the Apocalypse deals with the visions experienced by the apostle St. John, many of them concerned with the end of the world. In spite of their scriptural text, apocalypses seem to have been largely used as private secular reading. The illuminations often followed the text closely, as it offers many vivid images to depict.

MUSICAL MANUSCRIPTS

The gradual was the main choir book that was utilized during Masses; the antiphonal contained sung portions of the Divine Office. All medieval churches would have had both books, which were usually large, commonly measuring about 24 in. x 14 in., so that the whole choir could gather around and sing from the one text. The musical notation was written in black on four- or five-line staves, these usually being shown in red (although the very earliest choir books had no staves). But there were no bar lines.

LIVES OF SAINTS

These recounted episodes from saints' lives, both real and apocryphal, including miracles and martyrdoms. The texts of their lives became increasingly popular following the production during the 13th century of the *Golden Legend*, a compilation by Jacobus de Voragine of saints' lives, and that of the Virgin Mary. They served as models for saintly behavior, but primarily saints were seen as links between mortals and God, many of them acting as patrons or protectors. Lives of saints were often kept with the relics at the shrine of the saint, extracts being read out to pilgrims, while others were written for private lay reading.

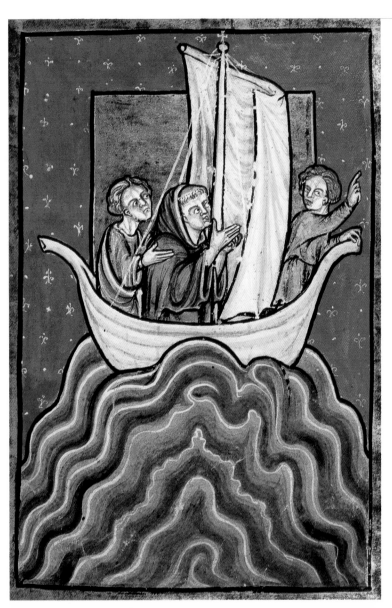

An illustration from Bede's Life of St. Cuthbert, showing the saint on a sea voyage.

meulx aduifee et fi remerchiee ne dame fen eft moult grande
de voftre deliurance monfeigneur ment acquittie de vous aydier.
de bourbon et monfeigneur de Le feigneur de clary re
coucy car ilz ont moult fort en pondy en telle maniere et dit
tendu pour vous. Et auffi la grans merciz a meffeigneurs
conteffe de faint pol car la bon mais ie cuidoie auoir bien fait

Comment les iouftes de faint fut trefbel et bien eftoffe lequel
Inglenerch furent emprifes/et Il auoit donne aux dames et a
des faiz darmes par meffire Re damoifelles de ladite ville de
thiault de wie meffire bouchi montpellier furent recordees
cault le ieune et le feigneur de et mifes auant toutes ces paru
faint pij. Le roy de france fe lees lefquelles ie vous ay recordees
Et la caufe pourquoy elles fure
jouenant en la bo la de nouueau retraictes Ie le vo
ne ville de mont duray. Lentente eft que ie vous
pellier en eflatemens et reuua ay commencie a parler de troiz
ainfi comme il eft cy defus uaillans cheualiers de france
contenu a vng banquet qui Ceftaffauoir meffire bouchi

HISTORIES AND CHRONICLES

Medieval royalty and nobles enjoyed studying history, both ancient and contemporary, actual and imagined. They took great delight in biblical histories as well as the classical histories by Livy and Herodotus, and in the stories of Troy, and of Alexander the Great (two particular favorites). Royal and noble patrons were anxious to trace back their lineage to known and heroic figures, and to bask in their glory. Several of the texts spanned enormous lengths of time, many from the fall of Troy to the present time, others from the beginning of the world! Contemporary events occurring to their own families and nations, recounted by the chroniclers of the day—events they had personally observed, or those recalled by others—also provided colorful reading.

Froissart, the late 14th century Flemish chronicler, wrote vividly of the events of his own times, which he described in his Chronicles with great and graphic detail, in particular battle scenes and skirmishes; the one illustrated shows a tournament.

ANTIQUE TEXTS

There was a vast legacy of Antique texts throughout Europe during the Middle Ages. Latin and Greek copies of classical history, philosophy, poetry, geography, and natural history were collected, translated, and read by both churchmen and lay persons.

The writings of Ovid, Virgil, Horace, even Terence's bawdy plays, were translated, copied, and illustrated. Of the writings of the great classical philosophers, Plato and Aristotle in particular were studied, debated, and discussed by Church and universities alike.

A French text from 1500 illustrating a scene from Virgil's Aenead, in which we see Dido, the Queen of Carthage.

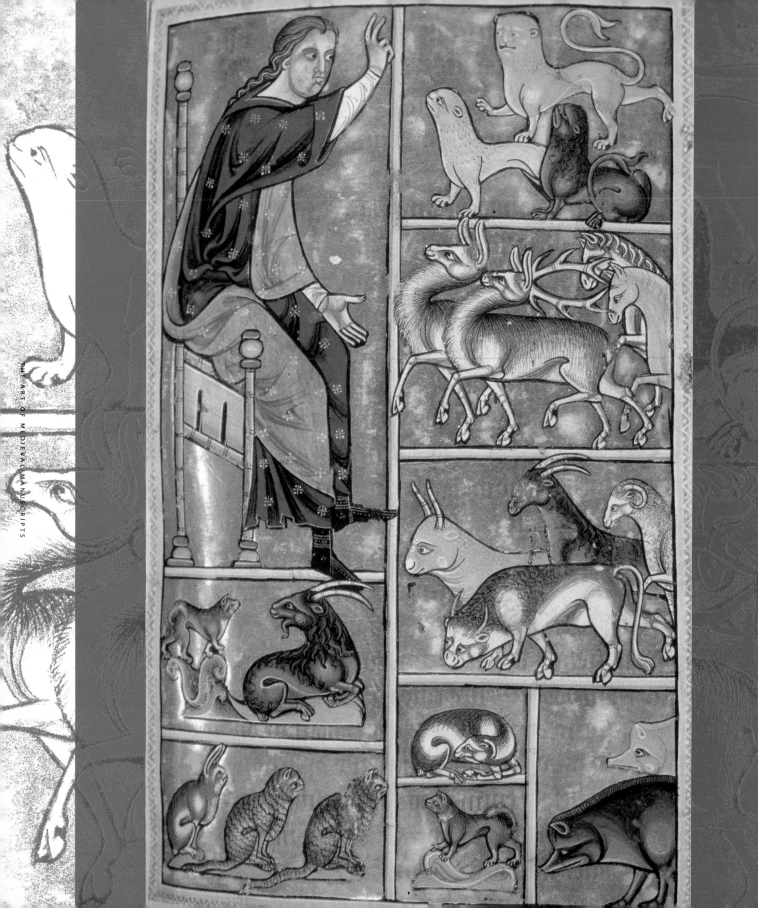

BESTIARIES

Bestiaries were books for private use, containing descriptions and tales of animals, birds, and imaginary and fantastic creatures. The texts for bestiaries drew heavily on the Greek text, the *Physiologus*, thought to have been compiled in the 2nd century BC and which was translated into Latin in the 5th century AD.

Each text carried some symbolic meaning and a Christian moral which would have been known to most readers, for similar images occurred in religious texts. Bestiaries were particularly popular in England in the 12th and 13th centuries, for with their large quantity of illustrations, the general yet obscure information contained in them, and their link with texts of antiquity, they fulfilled a need for 12th century readers, who were hungry for knowledge. They were also ideal general texts to be read from aloud, for they were among the earliest books to be written in the vernacular.

From a 12th century bestiary to be found in the collection of Aberdeen University, Scotland, showing various animals and a seated man.

HERBALS

Herbals, largely books of science and medicine for practitioners, with few illustrations, were based on texts of Apuleius and Dioscorides. They dealt with culinary and medicinal properties of plants—flowers, herbs, trees, fruit, and vegetables. Some also contained advice on behaviors and moods—anger, shyness, drunkenness—and other aspects of living (for instance, too much horse-riding) which caused sickness both of the body and mind. Remedies included not only foods and medicines, but singing (particularly the psalms!), dancing, and even meditating.

Later illustrated herbals, some also drawing on the work of the 11th century Arab teacher Ellbochasim de Baldach and produced for lay people, give us insights into the daily lives and seasonal rhythms of people in the Middle Ages; they deal with the planting, gathering, and storing of plants, how to prepare meats and fish, and questions about clothing, the heating of rooms, and the taking of exercise.

ROMANCES AND LITERATURE

Romances, recounting tales of heroic deeds, great adventures, love, and courtly behavior, were the most popular secular texts of medieval times. For centuries the stories of King Arthur and his knights, and of Tristan and Isolde, had been retold and sung by troubadours and other traveling minstrels in the castles and courts across Europe.

The written texts, first appearing in the 12th century in vernacular verse, served several purposes. Firstly, the enjoyment of hearing well-known stories read. Secondly, they coincided with a time of uncertainty for feudal aristocracy; knights' livelihoods were under threat, which made the valiant deeds of the past seem very romantic. Finally, they presented a mode of behavior that these knights—mostly unattached young men—should adopt to be accepted into polite society, and into the company of ladies.

They opened up artistic possibilities far beyond the confines of the religious texts. The texts were lavishly illuminated, and if the reader's literacy was limited, stories could be understood from the illustrations.

Contemporary medieval literature began in the 14th and early 15th centuries. Dante, Petrarch, Boccaccio, and Chaucer all enjoyed instant success, their works being widely copied and illustrated.

From the Tacuinum Sanitatis, early 15th century. Fennel being "cold and dry" and "good for eyesight and fevers."

A manuscript from the 1470s shows Lancelot and Guinevere stealing a kiss; as often in romances, the illumination is within the text.

A 15th century Italian manuscript of Boccaccio's romance Il Filocolo, *showing a typical Italian Renaissance town and a group of young men with their horses.*

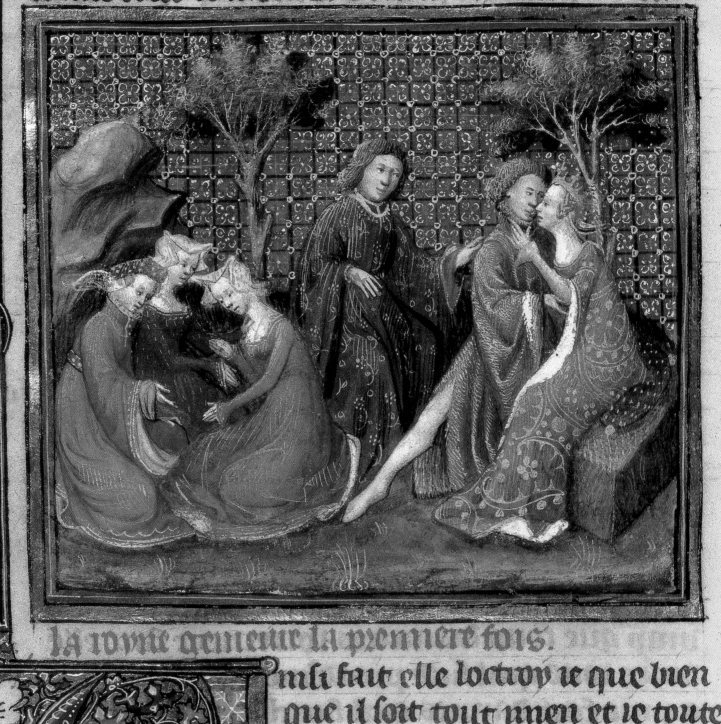

la roÿne demeure la premiere fois.

nſi fait elle loctroy ie que bien
que il ſoit tout mien et ie toute
ſienne et que par vous ſoient
amendes tous les meſfais et
les treſpas des conuenances.
Dame fait galaot grīt merits
nais que y ſourent commencement de ſeurte

A French 13th century manuscript showing a group of students being taught.

STUDENT TEXTBOOKS

Student textbooks were produced in ever-increasing numbers from the 12th century onward. Intended for study, they were relatively cheaply produced, with only a few decorated or historiated initials.

The books covered subjects taught at the universities: theology in the form of the Bible and all its attendant commentaries; law, both secular and ecclesiastic; medicine; arithmetic; astronomy; logic; and grammar. Some were pocket-sized, others vast and heavy, and there are tales of wealthy law students at Bologna coming to lectures followed by their servants laden down with books.

2 HOW ILLUMINATED MANUSCRIPTS WERE PRODUCED

D

There are many stages in producing a manuscript and – certainly by the later middle ages – a variety of craftsmen, with differing skills, were involved. The finished product was a major collaborative effort, from creating the quality of parchment needed, through the design of the pages, the copying of the text, the planning of the images, the illumination, to the binding of the book.

PARCHMENT

Parchment was made from the skin of an animal, probably mostly cows, sheep, and goats. The animals' "rectangular" shape dictated the shape of the books—a convention we still have today.

The skins were washed, soaked in a solution of lime and water, rinsed to loosen the hair, scraped clean, stretched on wooden frames, dried, and scraped again to create a thinner parchment, considered to be of higher quality. Last of all it was rubbed with chalk, rolled up and then stored ready to be used.

The finest manuscripts are made of almost transparent parchment, made from the skin of very young animals. When the skin of young calves is used, it is known as vellum.

By the 15th century paper was being used, but for the cheaper books produced for students, and for other non-luxury common texts.

GATHERINGS AND THEIR COVERS

The parchment skins were formed into collections of "sheets," known as gatherings or quires, usually of 16 folios or pages. These were made by folding a rectangle of parchment once, twice, or three times in half, to create shapes known as bifolios (the largest, folded once), quartos (folded twice), and octavo (the smallest, folded three times).

PREPARING THE PAGE

Before any writing or decoration could begin, the pages of a gathering had to be ruled, to ensure the text was even, and that the appropriate spaces had been left for the various elements on a page.

First, pricks were made, probably by a sharp metal instrument, through the thickness of a gathering, to align the rules on every page. Then lines were drawn across the pages, which can still be seen in many manuscripts, drawn in metallic lead or colored pigments. A 9th century instruction book on layout even gives the mathematical proportions for layout of pages, and mentions the width to be left between lines to accommodate scripts of different sizes. The number of columns in texts varied. Where a book was intended for public use, to be read from aloud—for instance the Bible, or many secular books—the text tended to be in two or even three columns, to make the reading easier.

THE WRITTEN TEXT

The scribe was the first person to work on the pages of a book. The term "manuscript" derives from his or her (for there were women scribes) task, which was to write (Latin *scribere*) by hand (Latin *manus*). The scribe's task was mostly one of copying texts from other manuscripts, and the texts to be copied were borrowed from various sources. It is important to remember that most medieval books were copies of other copies of texts. There were few entirely new texts until the later Middle Ages, and most illustrations depicting scribes from this period show them copying from exemplars.

At the end of a gathering, the scribe would write, in a tiny script at the bottom of the last folio, the beginning words of the text to be continued on the next gathering, and this can still be seen in many manuscripts.

Scribes wrote with a quill, made of goose or swan feathers, because they had the best flexibility, were the strongest, and could be sharpened easily, and a hard-working scribe would sharpen his pen many times a day. They wrote in ink, for which there were several recipes. One type of ink was made of charcoal. Another was iron gall ink, made from oak apple and ferrous sulphide (vitriol), mixed together to produce a dark ink which burned itself into the parchment and then darkened further when exposed to air.

Most texts were written in black. Red "ink" or pigment (made from vermillion ground with the white of an egg and gum arabic) was used to indicate opening and ending lines of texts, larger script which acted as a "heading," and rubrics (extended captions) which were explanations of illustrations, or instructions. Red was also used in the calendar pages of psalters and books of hours, to list the important saints' and feast days in every month—hence the term "red letter days."

Eadwine, a Benedictine monk and 12th century scribe from Christ Church priory, Canterbury. The inscription, from a page of the Canterbury Psalter, calls him the "prince of scribes."

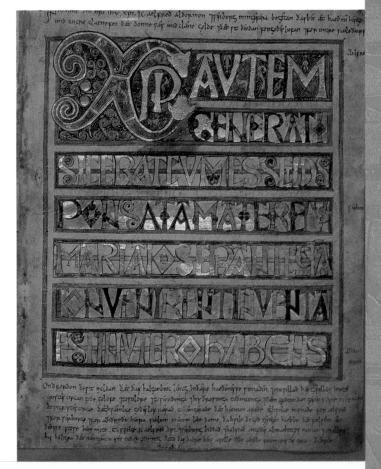

Gold text raised a manuscript's value; this page is from the Codex Aureus, a spectacular 8th century Gospel book.

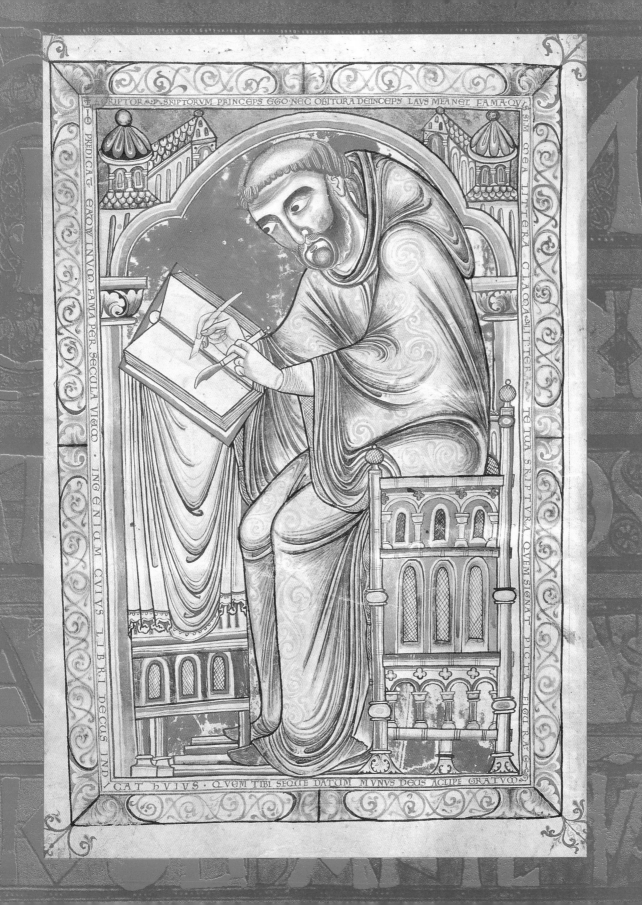

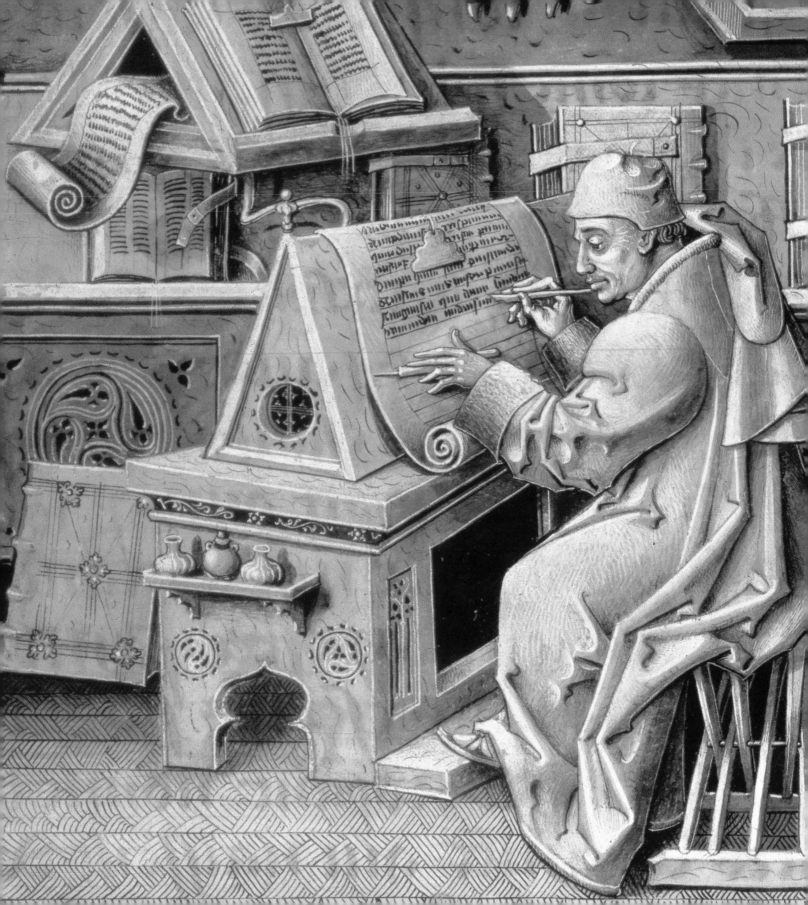

WHO WERE THE SCRIBES?

Many of the earliest scribes were monks and nuns who worked in monasteries in a scriptorium. Eadwine, the monk from Canterbury, is one such monastic scribe. By contrast, Charlemagne's scribe Dagulf worked in the royal household, and called himself a "*scrinarius,*" that is, a type of archivist.

In many instances, these earlier scribes were also the artists. Matthew Paris , the chronicler-monk of the Abbey of St. Albans in the 13th century, signed himself as the artist of chronicles he wrote. And a 12th century nun inscribed a manuscript she worked on with the following: "Guta, a sinner, a woman, wrote and painted this book."

By the late 12th century an increasing number of lay men and women worked as scribes in lay workshops, some also following other trades and professions: full-time students, priests, and lawyers needing more income, even inn keepers and the inmates of debtors' prisons. One 13th century Parisian scribe who specialized in copying romances was Colin le Fruitier (the greengrocer). Lay scribes tended to be based in the university towns of Oxford, Paris, Padua, and Bologna, where the demand for students' books was enormous. Many worked with booksellers, who in turn worked under strict rules and controls imposed by those universities. Scribes also worked for the royal courts.

By the 15th century many noble households employed scribes who combined a range of writing and translation duties, as well as specializing. One Antonio Marco, for instance, specialized in copying historical texts, and numbered among his patrons Cosimo de Medici, a bibliophile. Italian scribes also increasingly signed their work.

Jean Mielot, a 15th century scribe and secretary to Philip the Good, Duke of Burgundy, works in his study copying from an exemplar. His study full of manuscripts, he looks rather more comfortable than Eadwine (page 31).

DIFFERENT SCRIPTS

Scripts changed significantly over the medieval period, as the demand for more readable, smaller, and portable books grew.

Insular majuscule script, consisting of uncials or half uncials, (i.e., all majuscule or upper-case letters), is the large, "square" script of the 8th century Lindisfarne Gospels, where there are no divisions created between the words.

During the early 9th century, Charlemagne encouraged Caroline miniscule to be adopted as the uniform script used by the copyists throughout the Carolingian empire, and the script's clarity was the main reason for its adoption. It had a very rounded appearance, with small letters and tall vertical ascenders and descenders (as in "d" or "p"), developed from Roman writing of the 4th and 5th centuries. To write this script, a scribe had to cut a pen straight across its top.

Gothic script was a 13th century development of Caroline minuscule, with very decorative angular letters, both majuscule and minuscule, and letters extending above and below horizontal drawn lines. Curves were replaced by acute angles, and letters formed of thin lines and thick strokes. This variety was achieved by the head of the scribe's pen being cut at an oblique angle.

This script was used almost exclusively in manuscripts for the next two centuries, until Italian Humanists began to seek a newer, neater script, easier to read. What they rediscovered (thinking it was Roman!) was the round Caroline minuscule which they perfected. By the middle of the 15th century, this new style—known as Roman—had replaced the gothic script, particularly in Italy, and became the foundation for a great number of printed typefaces.

Elsewhere, the gothic script was retained for most religious texts, and was the script of the first printed Gutenberg Bible.

Scribes in the early medieval period did not necessarily know how to read; writing and reading were separate skills. As a result, mistakes were made, and manuscripts often have corrections written in the margins, or inserted into the text. There are also comments written in the margins by the scribes correcting texts: "This page was not copied slowly," and other comments such as "This lamp gives bad light" and even "This parchment is certainly hairy."

...lequentes p...	s Princeps des crel tien
...hymne de...	age doubter mer pour
...Eterna p...	u est le sepulcre de no
...agimus atg...	ourer et le greuer hors
...detulit nos a...	carans chafcun chenab
...Nonum gr...	paigne fera tenus dy
...tribularunt por...	...unt fi porront bonner
...mutat...	t que le Prince de la d
...Gloria tibi...	u le dit heritage voie
...hodie omni p...	dit uoyage ou paffage
...nuptias fela a...	s autres Princeps creft
...in fine omn...	ounelment en la com
...p totas oct...	chenaliers feront tenu
	er continuelment tan
	ora falue fe aucune en

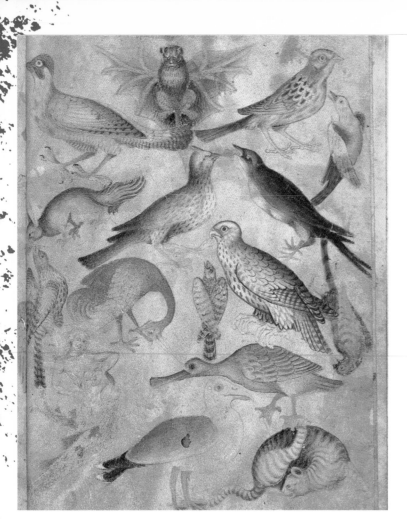

An artist's sketches of birds and wildlife, from which others would copy, from the Pepysian Model (or pattern) Book c. 1370-90.

THE DECORATION

Religious texts tended to be the most decorated; student texts the least. In some books almost every page has a decorative element; in others only a few opening pages of new sections are decorated. The main decorated elements are: miniatures, initials, *bas de page*, and borders. Line fillers and pen flourishes complete the repertoire.

Hugh of St. Victor, a 12th century churchman, explained the need for complex decoration: "It is of great value," he tells us, "for fixing a memory-image that when we read books, we study to impress on our memory . . . the color, shape, position, and placement of the letters . . . in what location (at top, middle, or bottom) we see something positioned . . . in what color we observe the trace of the letter of the ornamented surface of the parchment. Indeed, I consider nothing so useful to stimulating the memory as this."

DESIGN AND ICONOGRAPHY

The under-design for the decoration was first drawn with a hard point, graphite, or pen, often copying from an exemplum or from a pattern book (several still survive with birds, plants, and figures for the artist to copy). Original designs not found in pattern books were carefully protected; in a lawsuit in Paris, in 1398, the artist Jacquemart de Hesdin was alleged to have stolen paints and patterns from a fellow artist.

An artist would have had little choice over the subject matter, i.e., the iconography. For religious texts, an adviser would be consulted in discussion with the patron commissioning the manuscript, who would also have had requests about both text and illustrations. Some English and French manuscripts contain directions in the margins, such as "*une bataille cruelle*" (a cruel battle scene), or "*Adam qui labore et Eve qui file*" (Adam working and Eve spinning). Sometimes even the color was suggested: "Give Jesus a white robe here."

During the Middle Ages, there were many shifts and changes in religious thinking, which resulted in the iconography changing, often quite dramatically. One instance illustrates this well. The Nativity of Christ was, until the late 14th century, shown with the infant lying in a cradle or manger. But thereafter, following the vision of St. Briget of Sweden, the imagery changed, and the infant Christ was shown naked, often lying on the ground, and being adored by all around him.

There were many conventions in religious manuscripts widely known to artists and readers: King David from the Old Testament was depicted playing a harp or bells, St. Peter always had short, curly gray hair and beard, and various saints were portrayed with their known "attributes": St. Catherine with her wheel, or St. Sebastian being pierced with arrows.

Outline designs for capital letters showing "C" and "O," from a Model Book of Initials, Italy c.1200.

An inhabited initial "T," from a Cistercian manuscript c.1320, clearly showing the use of gold in the background of the illumination, although Cistercian illustrations were certainly less ornate than those of other monastic orders of the period, using less gold.

ILLUMINATION

The word "illumination" (from the Latin *lumen*, light) means creating light, which was achieved by the use of gold or silver, which both reflect light and make whatever they are ornamenting more luminous. Gold in particular had strong religious connotations of light and divinity in early Christian and Byzantine art.

Gold was used for the background in many miniatures and initials from the 10th century (and thus resembled early Christian mosaics) until the 14th century. But once scenes in miniatures became more realistic—which occurred in the mid-14th century—gold was used mainly as a highlight, though it still often formed the background in larger initials.

Gold was used in one of two ways: leaf and paint. In the first, extremely thin sheets of gold leaf were glued into place over a layer of pigment (usually red), or were placed on a sticky gesso (a plaster) to create a raised effect. After laying it on it needed to be burnished, usually with a tooth .

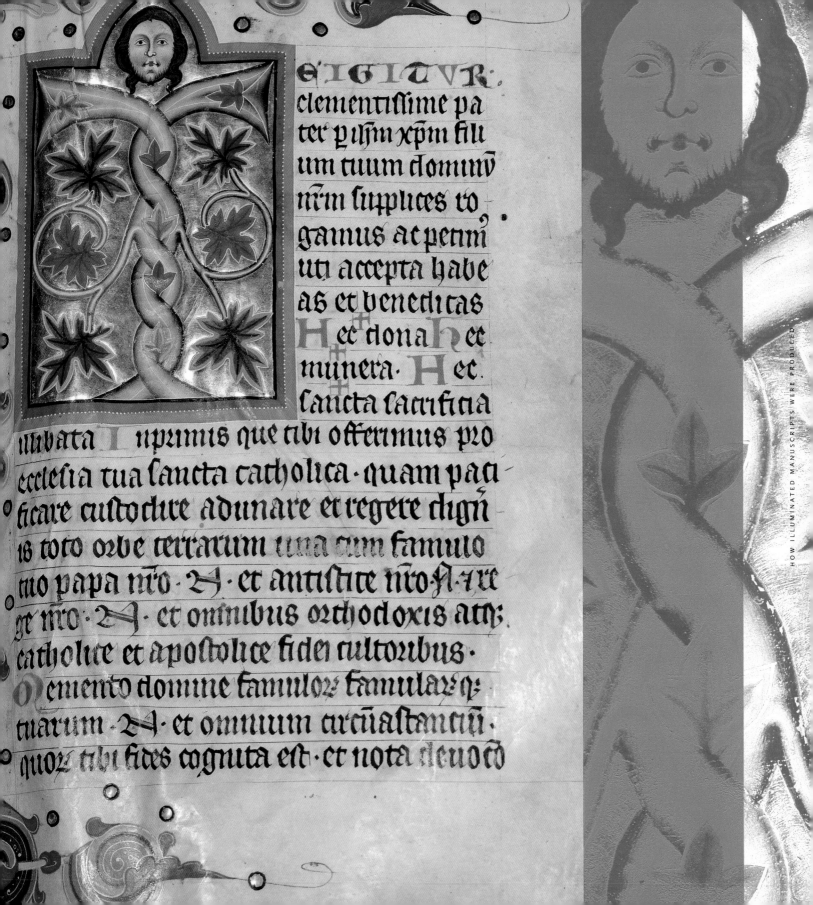

Te igitur. clementissime pater per ihesum christum filium tuum dominum nostrum supplices rogamus ac petimus uti accepta habeas et benedicas Hec dona Hec munera. Hec sancta sacrificia illibata Inprimis que tibi offerimus pro ecclesia tua sancta catholica. quam pacificare custodire adunare et regere digneris toto orbe terrarum una cum famulo tuo papa nostro . N . et antistite nostro N. rege nostro . N . et omnibus orthodoxis atque catholice et apostolice fidei cultoribus. Memento domine famulorum famularumque tuarum . N . et omnium circumastantium. quorum tibi fides cognita est. et nota deuocio

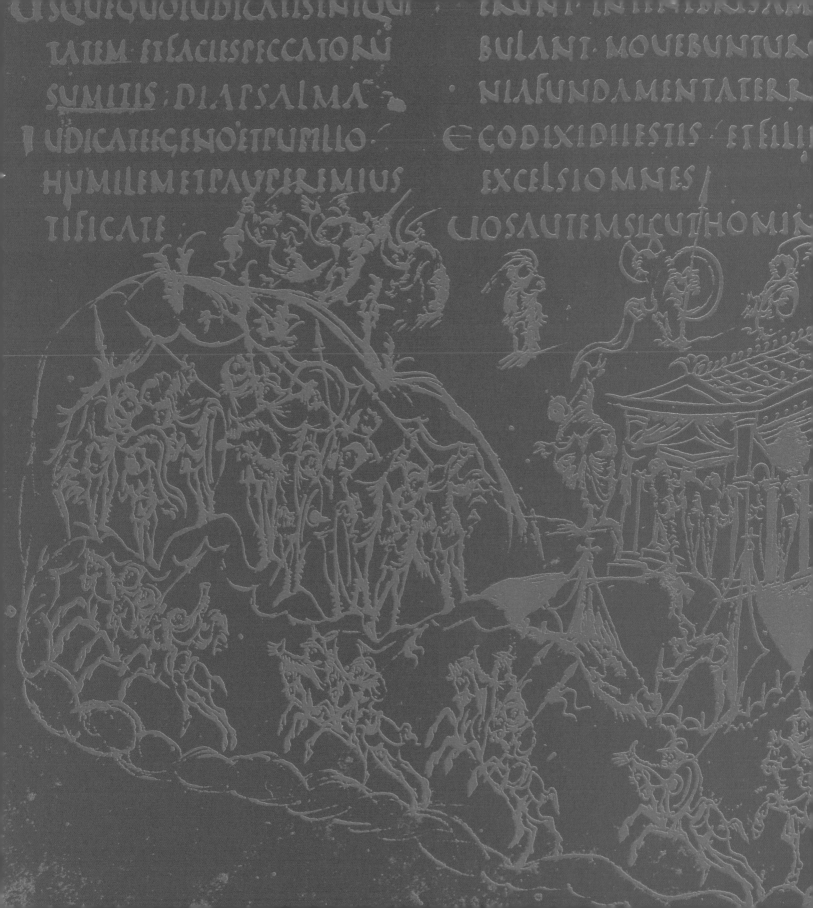

USQUEQUOIUDICATISINIQUI
TATEM ET FACIES PECCATORU
SUMITIS; DIAPSALMA
IUDICATE EGENO ET PUPILLO
HUMILEM ET PAUPEREM IUS
TIFICATE

ERUNT INTENEBROSAM
BULANT MOVEBUNTUR O
NIAFUNDAMENTATERR
EGODIXIDIIESTIS ET FILI
EXCELSIOMNES
UOSAUTEMSICUTHOMI

In these instances the gold was applied before other colors. When using gold paint, the artist applied it after the other colors.

Artists used a wide range of colors, made from minerals or organic matter. Reds were the most popular: crimson and vermillion. These came from lead, natural cinnabar, or other plant sources. Blue, the next most popular color, also came in various shades. Much of it came from azurite, a copper-rich stone which was crushed to a powder. A more transparent violet blue came from the plant turnsole. But the most prized and valuable was ultramarine, made from lapis lazuli, a stone found only in Afghanistan. It was very costly and was used only for the most important elements in a manuscript, for instance the robes of the Virgin Mary. Greens were obtained from malachite or the pigment called verdigris—a product of copper and an acid, either vinegar or urine. Yellow was obtained from saffron, and white from lead oxide.

The pigments would usually be bought from an apothecary, and then ground and mixed with glair (egg white) or gum to create paints. These paints were applied either by brush or pen. Brushes were made from animal fur, and for the finest work miniver (fine, white fur) was advised.

Many manuscripts were purposely illustrated with drawings, rather than fully painted miniatures. These drawings were done in ink, using a pen and brush, (the Utrecht Psalter is a good example of drawings done in brown ink) or in graphite. *Grisaille*, a monochrome painting using shades of gray, with black and white pigment, was used to give an impression of three-dimensional sculpture, or ivory carving, and was popular in the 14th and 15th centuries. (Jeanne D'Evereux's Book of Hours was executed in grisaille by Jean Pucelle, a Parisian illuminator.)

DECORATIVE ELEMENTS

Miniatures, the largest decorative element, varied over the centuries both in their size and where they were placed. In the earliest of manuscripts, they lay within the text panel. Thereafter it largely depended on their function. Where the prime purpose was didactic, the miniatures—full page or smaller—would be placed at the beginning of a text, or on a separate page. Where a series of miniatures themselves formed a narrative, they were often placed in close relation to the text. Sometimes they were framed, sometimes they were free-standing; elsewhere a miniature was replaced by a series of roundels or quatrefoils, all placed within a frame (particularly in the 13th and 14th centuries). Such was their variety that no generalizations are possible.

An historiated initial, illustrating the New Testament account of John baptizing Jesus, from the English early 15th century Archbishop Chichele's Breviary.

psalmū dicat noi tuo dūe. P. Ju
late deo ōis tra psal. vl' Des de la
nement. Ħres pine lc. de
saie legantur; Uemo pūna

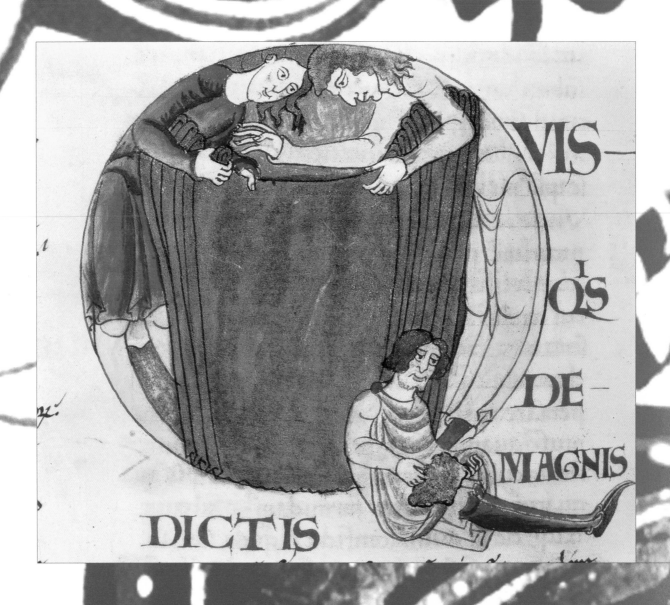

VIS—

I
QS

DE—

MAGNIS

DICTIS

Initials are the next major decorative element. Different sizes of initials served to guide a reader's eye through a text. So, in psalters and Bibles, opening sentences of particular texts would be introduced by a large initial, which could be full page size or five- or six-line initials. Initials then diminish in size until they are one line in height—the same as the text—and could be placed anywhere on a line.

There are three main types of initials: historiated, which contain a scene from a "story" familiar to readers; inhabited, containing human, animal or fantastic figures, but not identifiable; and decorated, with purely decorative designs.

The borders of pages often followed conventions of their period, sometimes being framelike, and others consisting of delicate flowers and leaves partially surrounding the text.

Although artists were constrained when creating the main miniatures and initials in religious texts (less so in secular texts), fewer conventions limited their imagination when it came to the *bas de page*—the space below the text but still often within the border. These illustrations often attract our attention with a variety of comic scenes and often fantastical creatures. Line fillers—the decorative elements which fill short lines of text—also allowed artists a free hand.

An historiated "Q" from the 12th century Cistercian manuscript Moralia in Job, depicting drapers, from Citeaux Abbey, France.

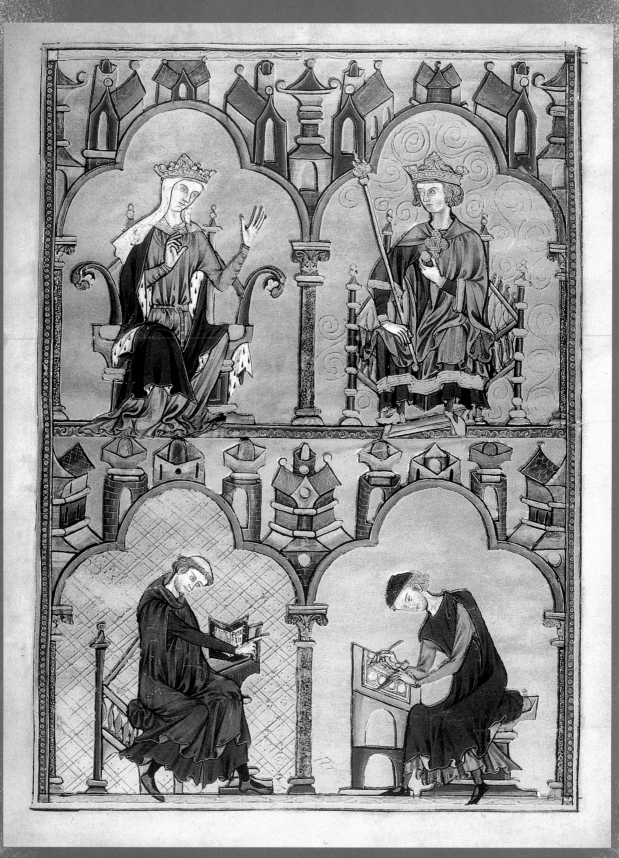

WHO WERE THE ARTISTS?

Artists in the early period were sometimes monks or nuns, or church-men, though lay artists also worked with them. By the late 12th and 13th centuries most artists were attached to lay workshops, often run by "masters." Some earlier artists were also goldsmiths—for the skill and delicacy involved in both crafts had many similarities.

The majority of the early medieval illuminators were anonymous individuals. Many are now simply known as "masters" of the manuscripts they illuminated, or by the names of a patron they served. Yet others are named from their particular artistic style. So, one of the artists of the Winchester Bible is known as the Master of the Leaping Figures; and the artist of the Bedford Hours is simply known as the Bedford Master, from the patron he served.

An historiated initial, with King David playing the harp, from the late 11th century Norman Carilef Bible, placed within typical Romanesque decoration similar to that found on capitals and doorways in contemporary churches.

The 13th century King Louis IX of France is seen here with his mother (top left), while below a religious adviser dictates to a scribe.

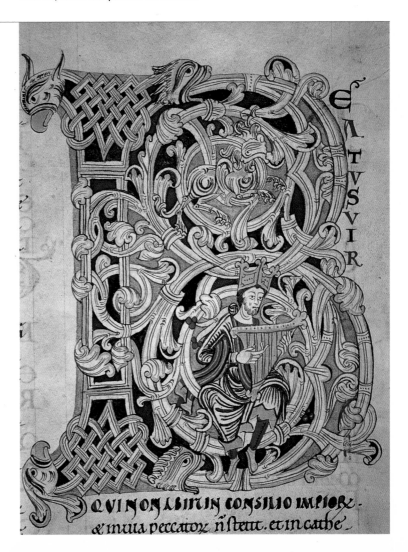

An historiated initial "S" from a choir book illuminated by Fra Angelico, showing the infant Jesus being received into the temple. The musical notation is clearly visible between the lines of words.

By the 14th century, artists were often employed by royal and noble households, and had formed guilds. By the 15th century the status of artists had risen, and more began to be known by name. Several, who are now better known for their panel and fresco paintings, would also illuminate manuscripts: for instance, Simone Martini, Jan van Eyck, Fra Angelico, and Taddeo Crivelli.

Frequently more than one artist worked on a manuscript. Where the illumination was a product of a workshop, the "master" would paint the main miniatures and initials, and leave the borders and lesser initials to a less experienced artist.

What does not seem to be mentioned anywhere is whether artists used eyeglasses of any description to help them work on the minute details in the illuminations, though spectacles were known and worn in Italy by the middle of the 14th century.

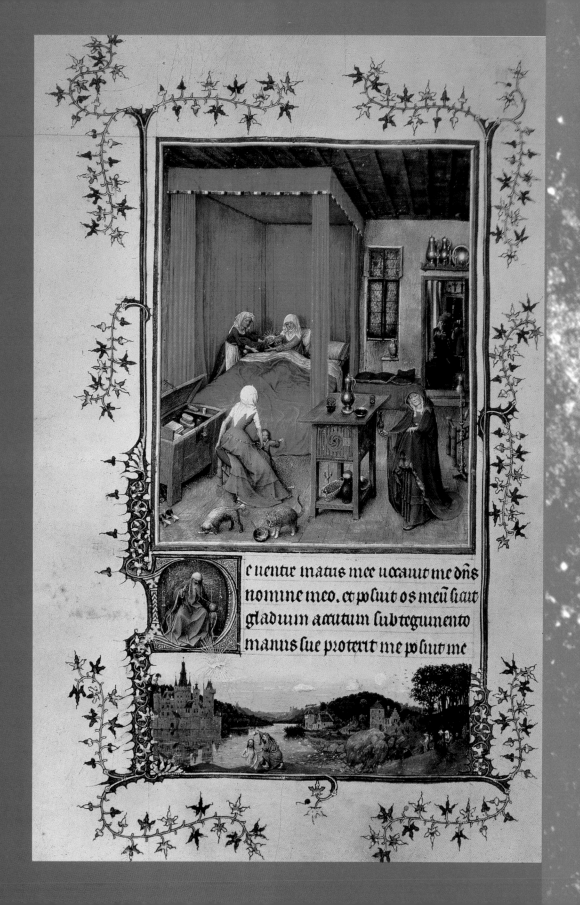

THE BINDING

Once the work of the scribes and artists had been completed, all the gatherings were sewn together and put between wooden boards, which were then covered with leather or a textile, and sometimes protected further with a "chemise" made of velvet, silk, or leather wrapped around them. The outer edges of the book were held together with clasps.

THE COST AND LABOR INVOLVED

Little is known about how long it took for a manuscript to be completed, how much it cost, and how much lay scribes and artists were paid. A few contracts exist, and these specify whether the patron would provide the materials, and board and lodging to the artist. One contract specified that the artist be provided with wine while "employed"! Monastic books, however, were never commercial enterprises.

In Padua in the early 1300s, scribes were paid by the amount of text in a gathering (known as a pecia): 16 columns (two per page), of 60 lines, each line with 32 letters. Yet time was important. A 400-page book could take a speedy scribe, using the gothic script, up to six months to copy. Writing in the new Roman cursive script, with letters joined up, and which became known as italic, scribes could complete their task faster. In 1462, one scribe claimed to have copied a text of Caesar in 38 days, which meant copying out eleven pages a day.

Artists were also paid by the job. Rates of pay depended on the size and complexity of the decoration, with separate rates for miniatures, main initials, lesser ones, borders, and *bas de page*. The amount of gold and type of pigments were important cost factors, particularly if the artist had to provide them himself.

Many manuscripts were completed over a number of years. The Winchester Bible was worked on for 15 years and was never completed, though the Benedictine monks who copied and illuminated it—albeit with lay artists—would have had other duties to carry out. The famous Tres Riches Heures of the Duke of Berri were completed in two phases by several artists over 60 years. And Borso d'Este's Bible took 10 years.

The 12th century bejeweled cover of the 11th century Sion Gospel, inlaid with 10th century enamels.

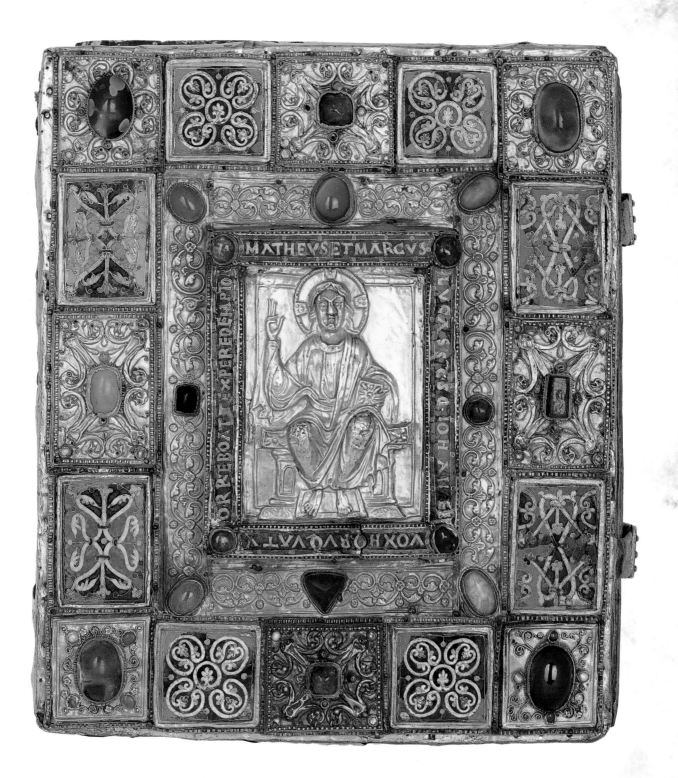

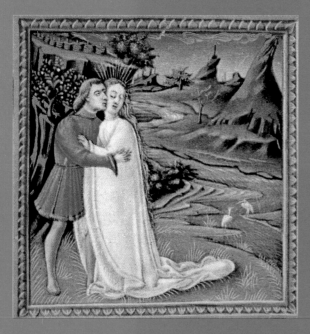

Anne of Burgundy offering her devotion very directly to the Virgin Mary in the book of hours that was made to celebrate her marriage to John, Duke of Bedford, in 1423.

Two lovers from an illustration from Borso d'Estes celebrated two-volume Bible, which he took on his journey to Rome in 1471 when the Pope conferred the dukedom of Ferrara on him.

THE PATRONS

A family scene from the Borso Bible, which contains over 1,000 illuminated pages, with scenes that are more to do with Borso's wealthy entourage than with biblical stories.

The cost of producing an illuminated manuscript meant that a wealthy patron had to commission and pay for each one. During the Middle Ages, patronage changed, from being the preserve of monastic communities and emperors, to churchmen or women on behalf of an institution such as a cathedral, and to royalty, nobles, and wealthy merchants.

Patrons often influenced the contents of the manuscript they were commissioning, either specifying, for instance, which saints were to be listed in the calendars of psalters or books of hours, and whether they wished themselves or the subsequent owner (if the book was a gift), or some other personal emblem (e.g. a coat of arms) or element to appear in the manuscript. Charlemagne, for instance, specified gold to be used for the text of the Godescalc Gospels he was offering Pope Hadrian on the baptism of his son.

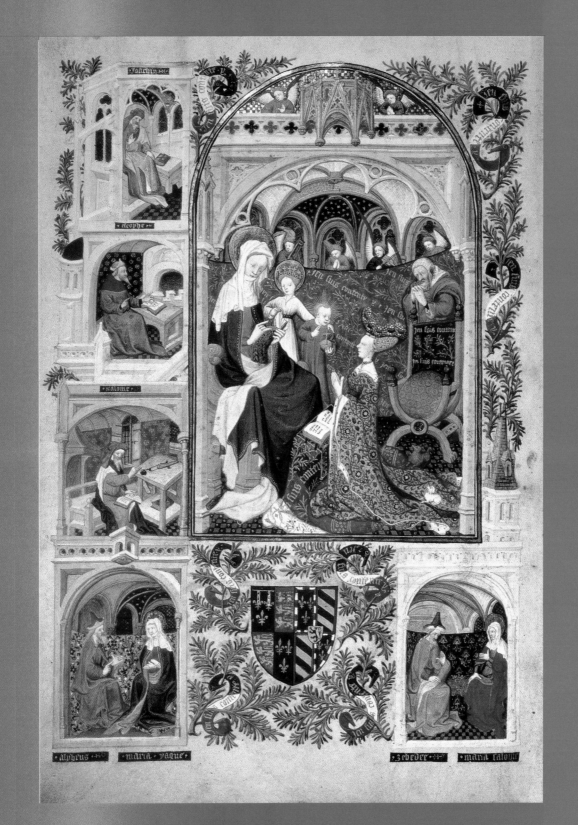

In religious manuscripts, patrons and owners are frequently depicted praying to either the Virgin Mary or a special saint. In early manuscripts they are shown as small figures, placed at a distance from the person to whom they are offering devotion, either in the border, or *bas de page*, as a sign of humility. Later—and particularly following the Fourth Lateran Council of 1215, which stressed the importance of individual devotion—patrons felt more able to place themselves closer to the person to whom they offered devotion.

In the 13th and 14th centuries, the French and English courts were a major source of patronage, as was the court of the dukes of Burgundy in the late 14th and early 15th centuries. Of 15th century patrons, the princes of the north Italian courts, and the Florentine Medici, stand out. Federigo da Montefeltro, duke of Urbino and a major patron, had the largest and finest library. He employed between 30-40 scribes, as well as some of the best known artists of the day. Borso d'Este, ruler of Ferrara, commissioned what is considered to be one of the most lavish manuscripts of the times—a two-volume Bible, richly illustrated by Taddeo Crivelli, and other artists. His motivation was no doubt at least as much personal prestige, as his personal devotion.

Secular patrons are frequently shown receiving books dedicated to them. Christine de Pisan, the renowned late 14th century writer, is here offering her book—perhaps the one with this actual illumination—to her patroness, Isabella of Bavaria, wife of Charles VI of France.

Pour ce liure cy que ie tiens

3 HIGHLIGHTS 750–1100

loc̄ · ꝯ ille non distat a monte moriā · ꝯ ꝉ itꝰ
unius diei · ꝯ ē inter bethel ꝯ hay ꝯ
Jn monte d̄ns uidebit · ꝙ · Sꝫ resp̄xꝰit
ysaac in monte · Sic uideat nos in hac
angustia · die ū libationis ysaac di
cunt hebrei p̄ma die septembris

During the early medieval period, manuscript illumination was very rich and varied. The manuscripts produced in this period were largely decorated religious texts - primarily bibles, gospels and psalters - for churchmen and rulers. The artistic centers included the Celtic and early Anglo-Saxon lands of Ireland, Scotland, and Northumbria, the vast Frankish empire of Charlemagne, the largely Rhineland and Italian-based empire of the Ottonian emperors, Mozarabic Spain, and slightly later Anglo-Saxon southern England.

The early Celtic-Saxon artistic tradition—known as Insular, which produced the famous early Gospel books, among them the Lindisfarne Gospels and the Book of Kells—is basically non-figurative. Ornamental and labyrinthine, it is characterized by clear linear elements and geometric interlacing. The entire surface of the page is filled, and zoomorphic birds, animals, and human figures appear, hidden among the decoration. Pagan and Christian images are combined, and similar designs are found on Celtic metal work. The art is an antithesis of the Antique traditions followed on mainland Europe, and it produced echoes for several centuries: in the borders of some Ottonian manuscripts, and more distantly in early 14th century East Anglian manuscripts, which are described in more detail later.

The Lindisfarne Gospels were produced in honor of St. Cuthbert by Eadfrith, bishop of Lindisfarne in Northumbria from 698-721. For church and ceremonial use, they may have been kept by St. Cuthbert's shrine. The red dot decoration is typical of Celtic-Saxon art, while the framing device to the right is a cat's body, replete with what seem to be ducks!

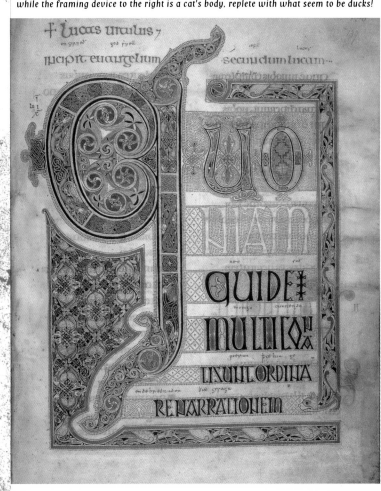

On mainland Europe, Carolingian art produced during the late 8th and 9th centuries received great encouragement from Charlemagne himself. One of its purposes was to help him to consolidate his vast empire and establish his position as a worthy Holy Roman Emperor. He also sought to establish links between the various monastic and secular centers throughout his lands, and create a sense of homogeneity in the texts by encouraging the standardization of the Caroline miniscule. For this purpose he brought in to work in his palace at Aachen, and in the dispersed monasteries, some of the greatest theological thinkers of the day—and notably the York scholar Alcuin—whose role was to oversee the production of the books.

Some Carolingian art was inspired by late Antique art, which was one way of helping the Frankish Carolingian emperors to maintain links with the antique past. There was a great variety of interpretations in the various centers of manuscript production, yet in all there is a great deal of energy, and the entire surfaces of the pages are richly decorated.

Palace-based artists employed by Charlemagne in Aachen created a style to match the splendor of the court, full of rich colors and influenced by late Antique art, yet with confidence and expansiveness. The use of light and shade in the illustration of the four Evangelists in the Aachen Gospels gives the impression of hills receding into the distance, and trees silhouetted against a pink sunset. The Evangelists, floating in a mist, are ethereal and yet very substantial.

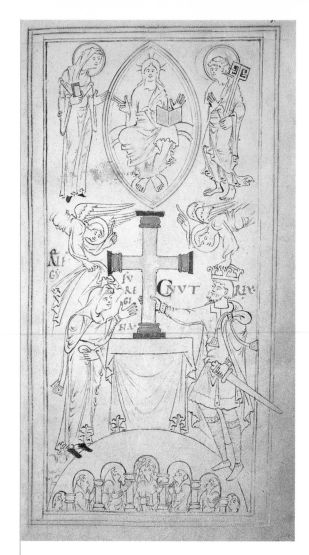

Liber Vitae; the Register and Martyrology of Newminster and Hyde Abbey, Winchester, with Queen Aelfgyfu and King Canute presenting a cross on the altar of Newminster, watched over by Christ, the Virgin and Saints c.1016-20. An 11th century English manuscript (see page 64).

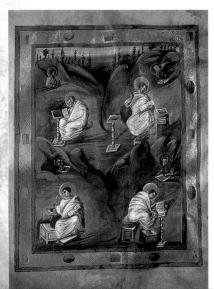

The Aachen Gospels had text written in gold. The Evangelists were placed in the four corners, to represent the four corners of the earth to which they were sent to preach.

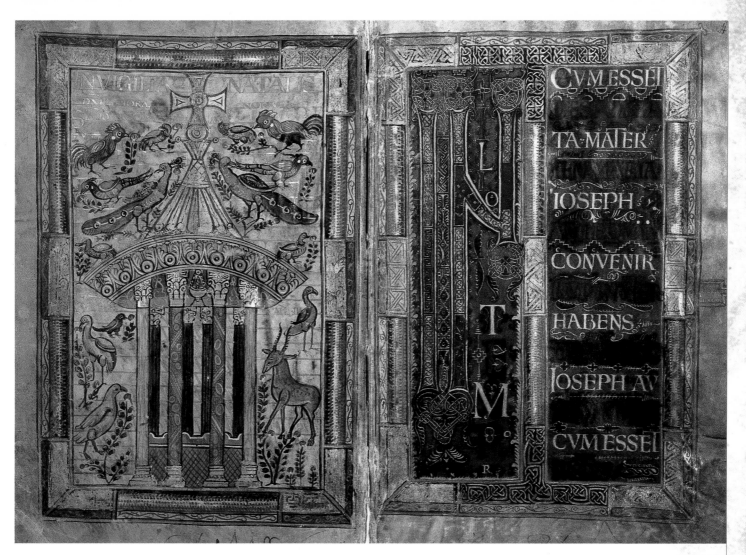

Commissioned in the 780s by Charlemagne to commemorate the baptism of his son Pepin by Pope Hadrian, the Fountain of Life depicts the waters of Eternal Life, full of birds and plants. The initials on the right folio show Insular influence. This manuscript was one of the first to be written in the new Carolingian minuscule script.

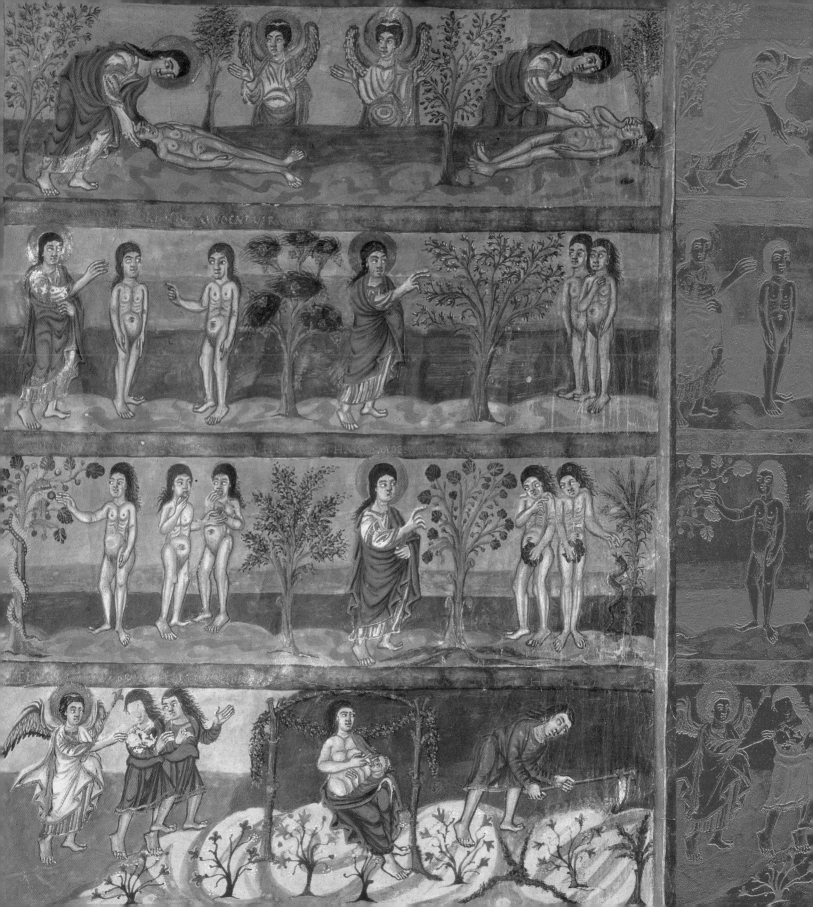

The Moutier Grandval Bible, produced at the monastery of St. Martin in Tours c.840, has only four full pages of illustration and 56 richly decorated initials. The opening miniature shows a cycle of the creation of man, his fall and expulsion from Paradise.

Another major Carolingian center of manuscript production was the city of Rheims, where the wonderfully creative Utrecht Psalter was produced around 820 AD. The liveliness of these ink-and-pen drawings, placed in landscapes of hills and valleys, and full of lively figures and classical-style buildings, again recalls late Antique art, but in a style all its own. The 160 drawings are unframed and the text is written in an Antique script. This psalter was copied three times over the next four hundred years in England.

The Carolingian period saw the production of many one-volume Bibles—the result of Alcuin's work of consolidating known biblical texts. Many of them were produced at Tours, where he was Abbot from the year 796 to 804. In some instances a story unfolds over the surface of a page, filling it entirely; in others, the narrative appears rather like a strip cartoon placed in bands down the page.

Text and illustration of Psalm 30 from the famous psalter of Utrecht c.820 AD.

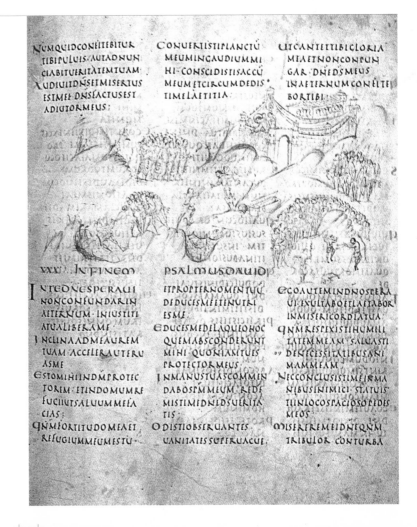

The next major developments occurred under the Saxon Ottonian Holy Roman Emperors in the 10th and early 11th centuries. Illuminations were much calmer, with more intense colors, and a greater sense of space on the pages. We can see Byzantine influence: gold background, and monumental figures which are more two-dimensional, holding a central position on the page. The Ottonian emperors had close contact with Byzantium, and Otto II married Theophanu, a Byzantine lady of high rank, who brought Byzantine artists to the court. These emperors, like the Carolingians, used art to convey their prestige, particularly their right to confirm the traditions of the Holy Roman Emperors.

These manuscripts exemplify an aspect of art which lasted well into the 14th century: The most important figures are always depicted as larger than others around them. Simultaneously there was prevalent unease over creating lifelike human images, resulting in a second strand to Ottonian art that replaced the images with finely decorated initials, symbolizing the words of the text they were accompanying.

Another wave of manuscript illumination came in England in the late 10th century, with the monastic reform movement, and continued up to the Norman Conquest in 1066. Anglo-Saxon art shared characteristics of Carolingian art—in particular in filling the page with color and figures, and adopting a classical, naturalistic emphasis. Early Anglo-Saxon artists created two very different styles. One relied on a high quality of draftsmanship to create drawings quite dazzling in their grace and exuberance. These, often tinted with color, created a very English style which continued into the 14th century.

The second style, named after the new Minster at Winchester, resulted in work with decorative frames and arcades ornamented with classical acanthus leaves, and Rheims-style figures enveloped in crinkly-edged draperies. Some depict biblical scenes, with great attention to detail in bands of color. The scenes of Christ's life in the ornate Benedictional of Aethelwold cover several pages, each of which precedes a text.

Another set of influential manuscripts was the Spanish Beatus Apocalypse. An 8th century monk, Beatus of Liebana, wrote a commentary on the Apocalypse. Over the next four centuries some 20 copies of the Beatus Apocalypse were illuminated by Spanish and other artists. On page 7 we can see an illustration from an Italian copy.

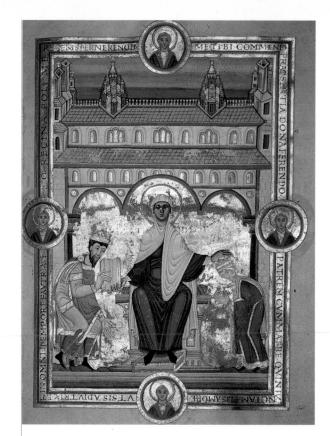

The Speyer Golden Gospels, c.1045 was commissioned by Emperor Henry III for the Cathedral at Speyer. At the feet of Christ are Henry's father and mother—a sign of how the Ottonian emperors interpreted their close links with God.

Otto III, crowned and sitting under a canopy (a sign of majesty), unmoving and almost Christ-like.

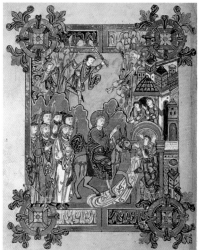

The entry of Christ into Jerusalem, from the Benedictional written by the scribe Godeman for St. Aethelwold, bishop of Winchester 963-84.

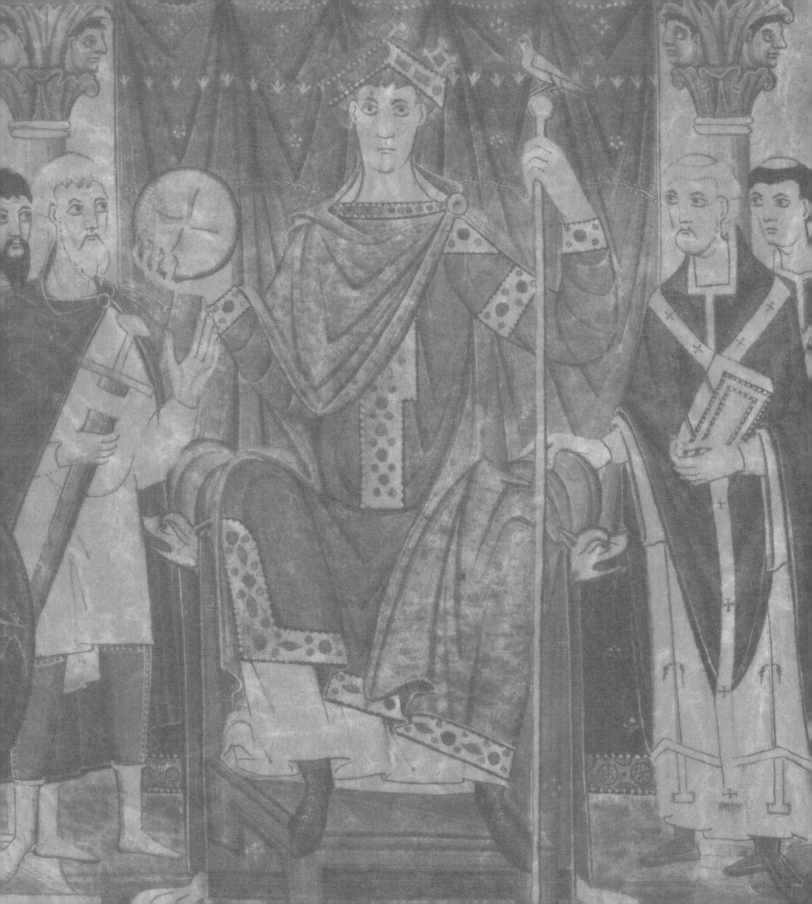

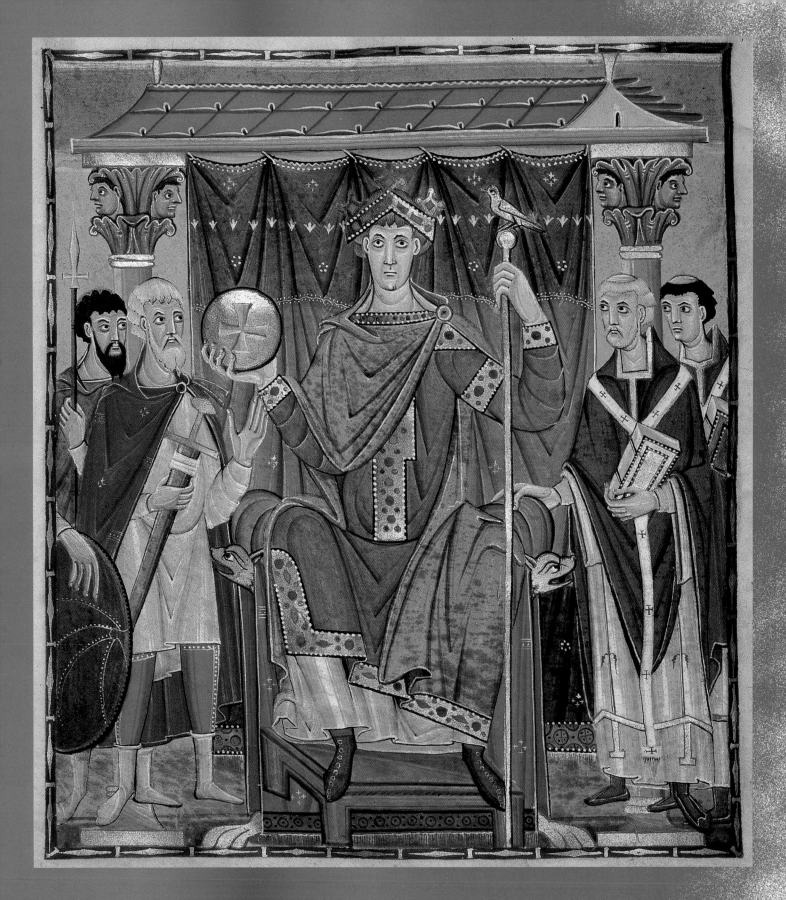

From the Tractatus de Vitiis Septem, a manuscript from the late 14th century, an example of a narrative illumination against a landscape, with people grouped around a fountain in the foreground and a well and house shown in the background.

These two large Beatus initials, introducing Psalm 1, are by two of the main artists of the Winchester Bible, one of the most glorious Bibles of the 12th century. One artist (known as the Master of the Leaping Figures) drew them, the other did the illumination.

A QUESTION OF BEAUTY

It may come as a surprise that many of these beautiful, jewel-like religious manuscripts were not created only as objects to be admired. The intention of the patrons and producers was to create objects whose beauty mirrored and reflected the beauty of God and his creation. Producing beautiful books was a form of devotion, in a time of deep religious beliefs and fervor. Their function, as the 13th century Dominican theologian Thomas Aquinas explained, was threefold: to instruct, to excite feelings of devotion, and to activate the memory.

In 600 AD Pope Gregory had pointed out that pictures were the "books of the illiterate" (in Latin), which enabled them to "read by seeing." And the majority of people were illiterate. Even those who owned books could probably read only haltingly. The same images, painted on the walls of churches and seen in stained glass windows, were used by churchmen in their sermons to explain difficult texts or abstract ideas in the Bible. Once the laity had understood their meanings, they could follow them privately in their own personal books of devotion. These

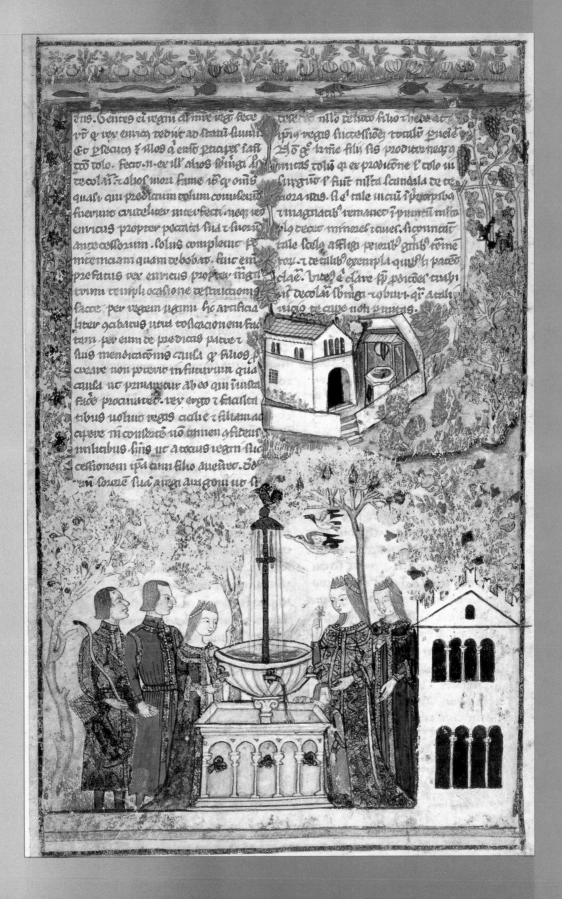

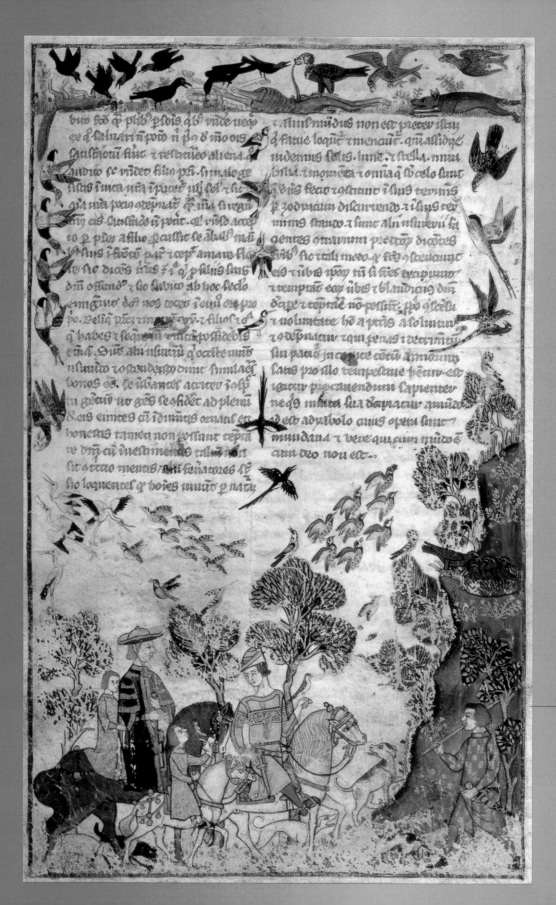

images were thus intended to create in people feelings of personal uplifting; an "internal" beauty in the reader created by the external beauty of the images.

The brilliant colors and gold in manuscripts also represented light (like the light that shone through stained glass windows). Thomas Aquinas had said that "things are beautiful when they are brightly colored." Light and brilliance were not only signs of the Divine, but were also loved by medieval people for their dramatic effect.

By the late 12th century philosophers, theologians, and in their wake lay persons and artists, were increasingly turning their attention to, and appreciating, the world around them, with—as one writer described it— "its wondrous light and color." The response of artists was to recreate in their work the world they saw around them—people, animals, plants, birds, and landscapes.

As the Middle Ages blended into the Renaissance, lavishness and beauty began to be appreciated for their own sake, while remaining strong status symbols. The librarian in Federico da Montefeltro's Urbino palace was instructed by the duke, who owned over 1,000 manuscripts, to show worthy visitors—and no doubt impress them with—"the beauty, features, lettering, and miniatures" of his renowned collection. Much had changed since Pope Gregory's times.

Similar to the previous illustration, this manuscript from the late 14th century carries an illumination featuring men and boys enjoying the popular medieval sport of hawking.

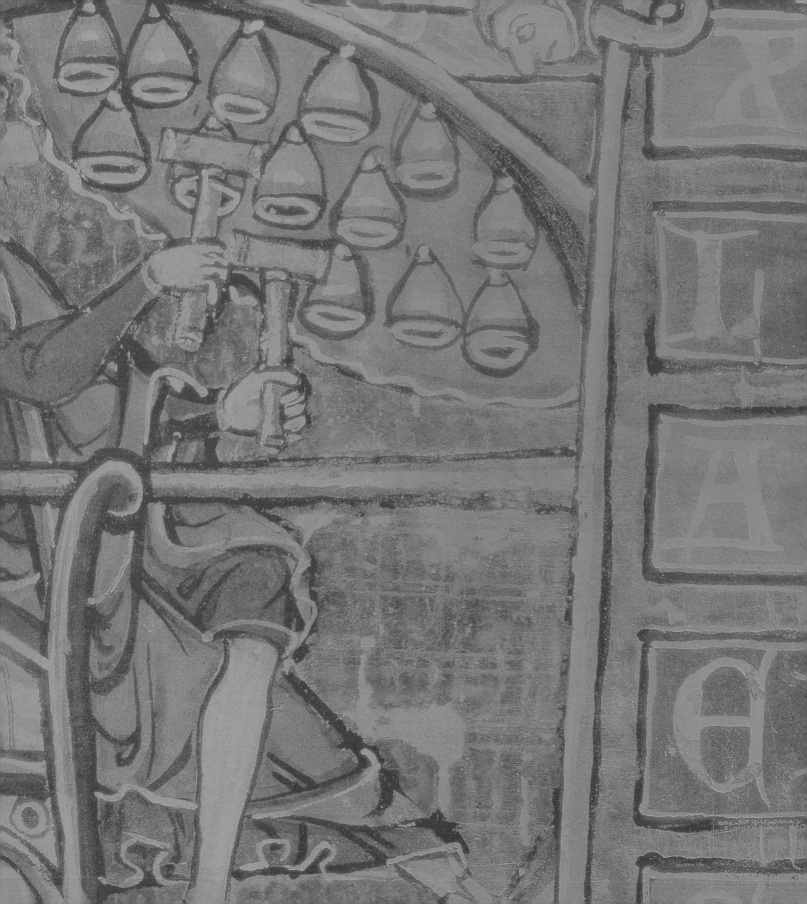

THE MAJOR CENTERS OF MANUSCRIPT PRODUCTION IN THIS PERIOD - WHICH WAS ONE OF THE RICHEST IN MANUSCRIPT ILLUMINATION - WERE ENGLAND IN THE ROMANESQUE PERIOD, AND FRANCE IN THE GOTHIC PERIOD. ROMANESQUE MANUSCRIPTS OF THE LATE 11TH AND 12TH CENTURIES WERE PRODUCED IN MANY CENTERS, MAINLY MONASTIC. MANY WERE ILLUSTRATED BY ITINERANT SECULAR ARTISTS (WHO NO DOUBT KEPT PATTERN BOOKS), AND THERE ARE REGIONAL VARIATIONS, ALL COMBINING MANY INFLUENCES. HOWEVER, THERE WAS A CONTINUING DEBATE WITHIN THE CHURCH HIERARCHY OVER THE USE OF REALISTIC REPRESENTATIONS OF THE HUMAN FIGURE. THE FEAR WAS THAT ANY LIFELIKE IMAGES MIGHT THEMSELVES BE VENERATED, RATHER THAN SERVE AS REPRESENTATIONS OR SYMBOLS. HUMAN FIGURES THUS OFTEN APPEAR TO US TO BE CRUDE AND SIMPLE, BUT THIS TYPE OF PORTRAYAL WAS DONE FOR A GOOD REASON.

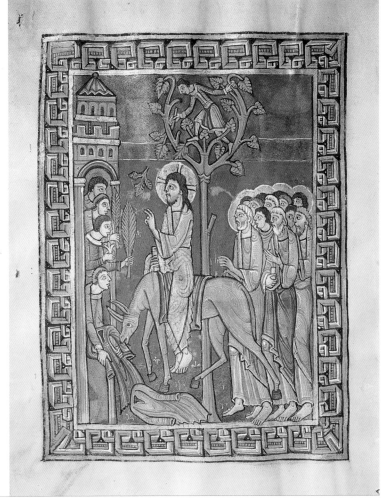

The Entry of Christ into Jerusalem: The St. Albans Psalter—one of the most lavish and influential of the 12th century—was probably produced for Abbot Geoffrey of St. Albans Abbey. He later gave it to the anchoress, Christina of Markyate.

Twelfth century England produced the outstanding manuscripts, in particular multi-volumed large Bibles. Following the Norman Conquest of England in 1066, manuscript production changed direction. The Normans sought books primarily for their texts, rather than for their illuminations. The word, and hence the initials, dominated. The initials in the late 11th century Norman Carilef Bible show how the artists had retained some of the earlier Anglo-Saxon vivacity and also point up the Romanesque love of surface patterning (somewhat reminiscent of earlier Insular art).

The return of the full-page miniature was heralded in the St. Albans Psalter, produced by the Alexis Master c. 1120-35, and his influence can be seen in many English manuscripts over the next 50 years: a figure style which is tall and statuesque, with defined contours, "beaky" noses

(a late Antique influence), and draperies which create a bandaged effect. Another influence on manuscripts of the 12th century came from Byzantine art, fostered no doubt by the contacts made by Crusaders, and by close marriage ties between the Norman court of England with Sicily and Saxony (both of which had links with Constantinople). This influence appears in the portrayal of the human figures in the initials of the Winchester Bible, and in the use of gold for the background. A similar influence appears in the work of the artist of the Lambeth Bible of 1145-55, with a rich gold background, though with a change in the figure style which is now more lively and swaying, and with an extravagance of line and pattern.

By the mid 12th century, the portrayal of draperies was distinctive, generally characterized by what is known as "damp fold" drapery, which clings to the body in swirls, as if literally damp, but which at the same time segments the body into almost geometric and spherical parts (to be seen also in the Lambeth Bible, and also in the angel's draperies in the Winchester Psalter).

The drawn and stylishly colored "portrait" of the scribe Eadwine from one of the three English copies of the Utrecht Psalter—which he himself copied—shows the continuing interest in England of line drawings. His chair and desk are decorated with Romanesque architectural details, such as the rounded arches (see page 31).

In Germany, manuscripts of outstanding quality were being produced at Helmarshausen, under the patronage of Henry the Lion of Saxony. In these can be seen the influence of gold and enamel work for which northern Germany was then famous.

By the late 12th century the concern of creating lifelike human figures had passed, and a more realistic figurative art blossomed, heralding the Gothic style, which emerged in the Ile de France. Its characteristics were more realistic human figures displaying a greater range of emotions and relationships, moving more fluidly, and placed in increasingly realistic settings.

Simultaneously, following the Fourth Lateran Council in 1215, the Church was encouraging the need for personal private devotion. This meant that illustrations in books of devotion, such as psalters (and later books of hours) had an increasingly didactic function, to help readers

The Winchester Psalter of around 1150, owned by Henry of Blois, bishop of Winchester, has a text of the psalms in both Norman French and Latin (Norman French was the language of the nobles in England at this period). This illumination serves as a reminder to an increasingly secular audience of the perils of the after-life, as the maws of hell contain a host of lay folk, a king, and queen—but interestingly, no bishop!

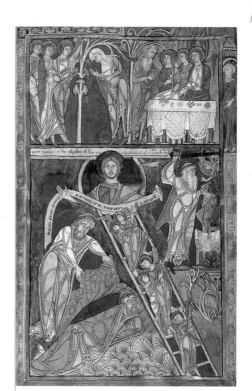

Another example of "damp fold" drapery, this illustration from Genesis of the story of Jacob's ladder is from the Lambeth Bible c.1140-50.

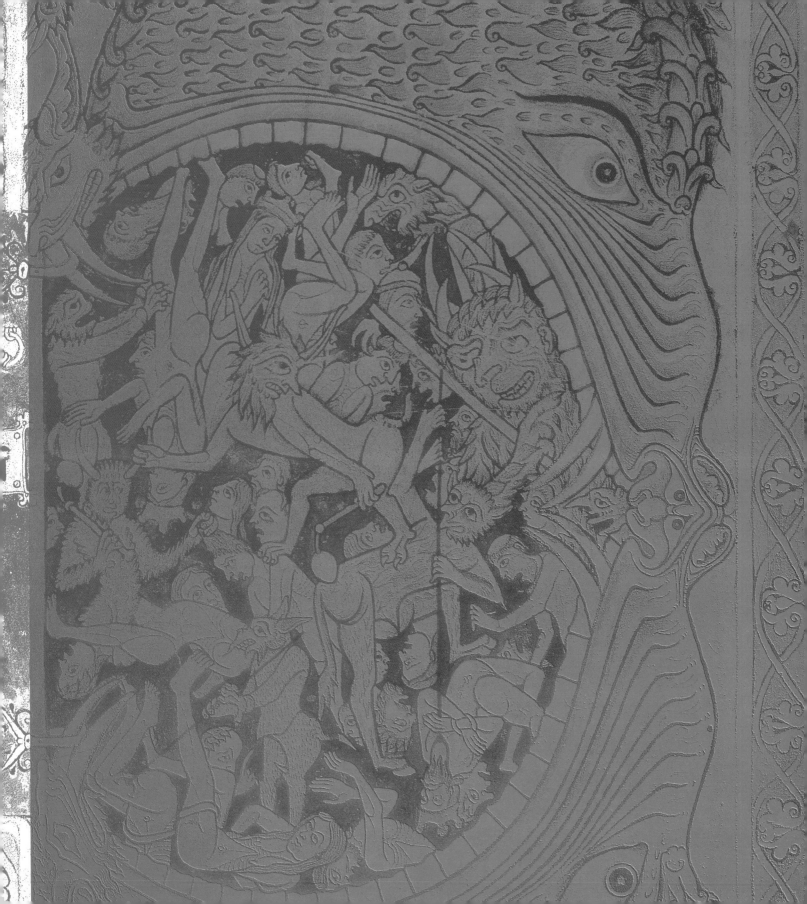

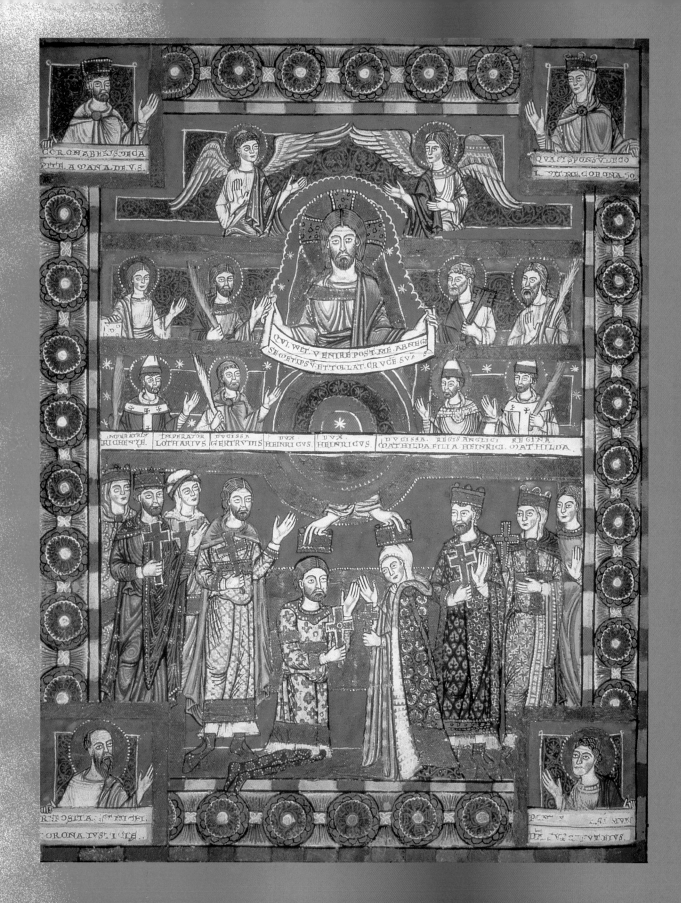

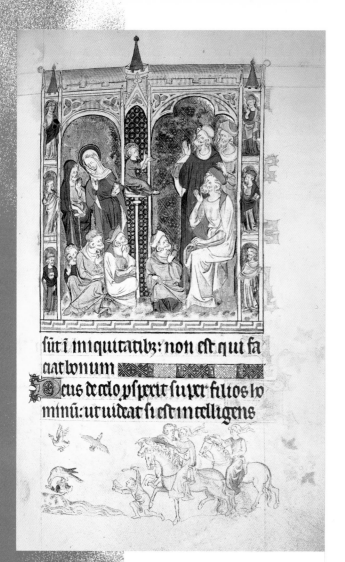

sūt ī īnīquītātībȝ: non est quī fa
aat bonum ▨▨▨▨
Deus de celo prspexit super filios ho
mīnū: ut uideat si est intelligens

The early 14th century Queen Mary Psalter
continues the English tradition of tinted
drawings, with a certain richness in some
of the miniatures. The figures are in a Gothic
architectural structure; their elegance, their
flowing draperies, the border decoration, and
the scene in the bas de page, are typical of
mid-14th century illuminations.

Produced c.1188, this page from the Gospels of
Henry the Lion shows the crowning of Henry
and his wife Matilda. The burnished gold
background is set off with rich greens, blues,
and reds. The Gospels were intended to be
displayed on the altar of the Virgin in
Bamberg Cathedral.

understand and relate to the messages of the text by portraying people more naturally, showing their reactions and emotions, and placing them in recognizable settings.

Representations of the human form saw several evolutions, changing from the tall yet stocky figures of the Romanesque period, to the very tall and willowy ones of the early French Gothic (seen in the St. Louis Psalter), which then developed into the typical "S" bend figures of the later 13th century (and still seen in the early 14th century Queen Mary Psalter). These elegant swaying figures are thought to have originated from the popular ivory carvings of the period (a Parisian specialty) which followed the curve of the elephant tusks. By the middle of the 14th century, the human form settled down to more rounded, realistic and varied representations.

By the 13th century, draperies fall in simple vertical folds, later becoming more complex and giving hints of a real body underneath. The human face and hair also change. In the 13th century, faces are simply defined and relatively featureless; hair is often shown simply by the drawing of wavy lines. Not until the 14th century is there any attempt to show individual features and emotions. By the mid-14th century, draperies are more voluminous.

By the mid-14th century a further visual change involved the placing and spacing of figures on the page, and in relationship to one another. In early Gothic manuscripts figures were very often not placed in any recognizable setting, and the background to them is frequently a "diapered" backdrop, a patterning of small diamond shapes usually in gold, blue, and red. Real space and settings—indoors and outdoors—gradually became more illusionistic, using perspective and thus giving a three-dimensional feel to the illustrations. The architecture of that period appears on the pages, as do clothes and other everyday elements. And the figures begin to relate to one another—a look, a touch, a head turned.

The subject matter of the manuscripts, and hence of illuminations, was also becoming more varied. The cult of the Virgin Mary was at its height and her life was one of the main themes of the popular Golden Legend, compiled by Jacobus de Voragine in the mid-13th century. She was considered to be an intercessor with Christ and God on behalf of

humans, and she performed miracles, saved individuals in trouble, and was the patroness of cities and cathedrals. There was an unprecedented outpouring of visual images associated with her.

In some respects there was now a certain uniformity in manuscripts, with fewer local characteristics. We find similar figure forms and portrayals of draperies. Page designs become more established, although borders of fine tendrils with leaves in French manuscripts are more delicate than English borders.

However, in the late 13th and early 14th centuries East Anglia and Flanders produced manuscripts—primarily psalters—with a lively and enigmatic quality all their own.

From the Belleville Breviary by the Parisian artist Jean Pucelle, who was the outstanding artist of the period. His miniatures were the first in north European art to show interiors in true 3-dimensional space, and his people were real, active, and emotional, with a quality new to manuscripts.

A miniature from the "Cantigas de Santa Maria," poems and songs in honor of the Virgin Mary, commissioned by Alphonso "el Sabio," king of Spain 1254-84. Alphonso listens to his court musicians, and dictates to his scribes.

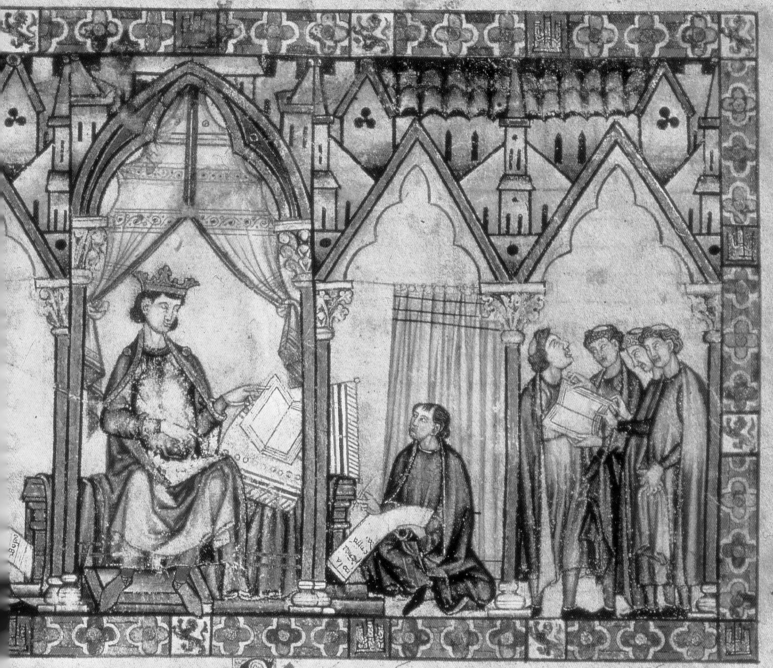

Esta e a primeira cantiga de loor de
santa maria ementando os . vii . gojos
que ouue de seu fillo.

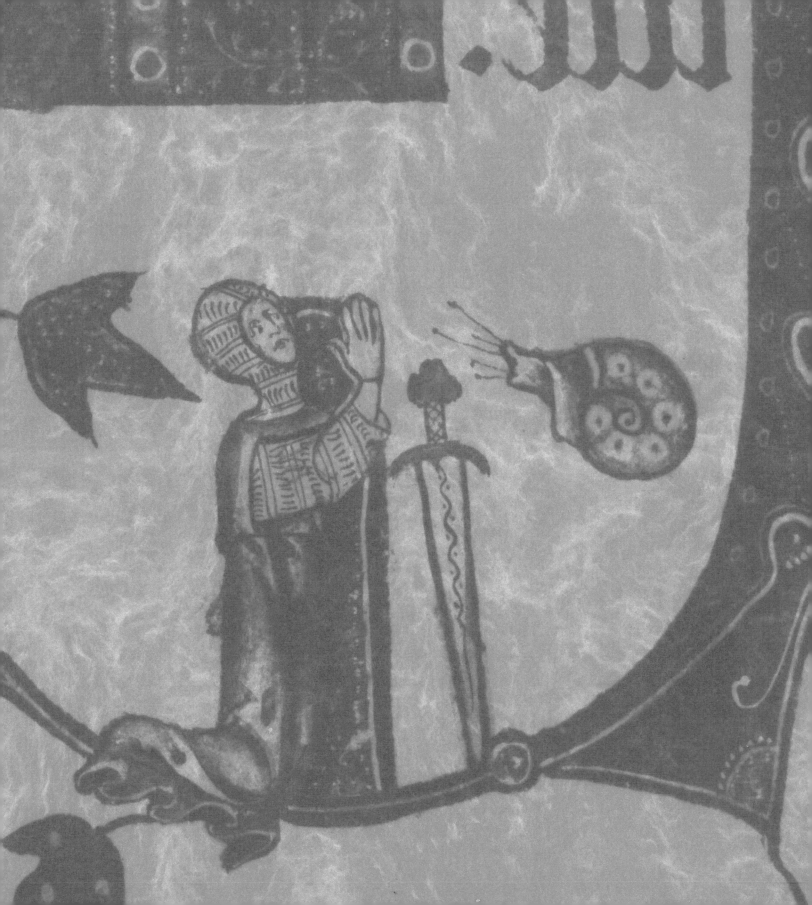

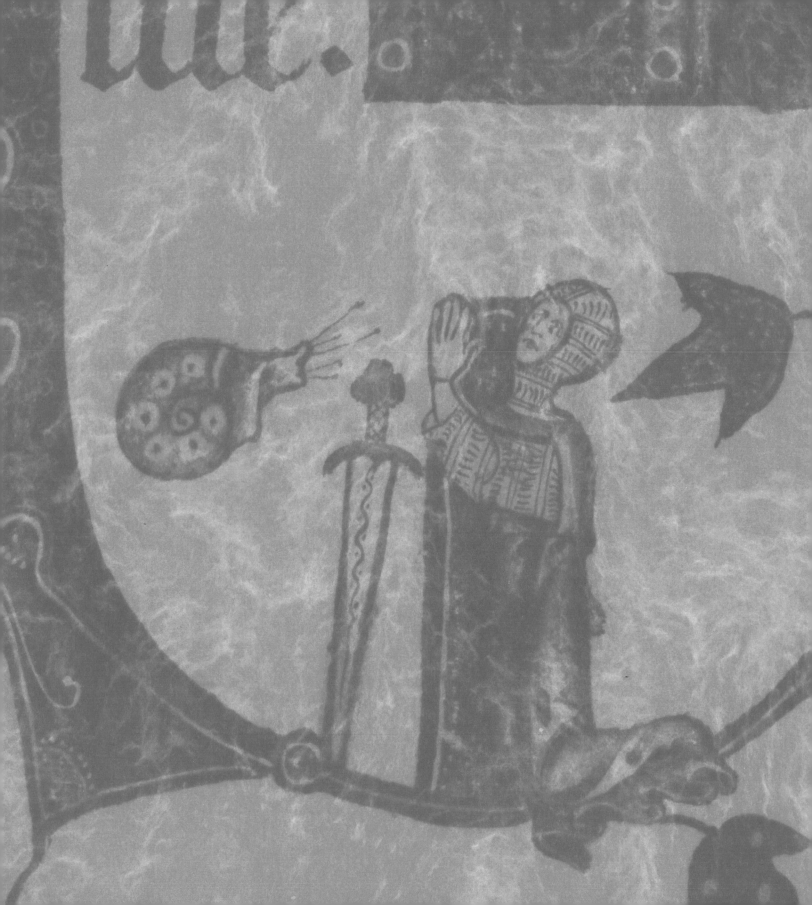

A strong influence on Church thinking, and hence on the art of the period, were the teachings of the friars—the Franciscans and the Dominicans—who stressed the value of the everyday world, and all the lessons that could be learned by observing it. We begin to see not only realistic humans, but also well-observed birds and animals in the borders and even in full-page miniatures (as in the Holkham Bible Picturebook).

The friars' emphasis on everyday life created an interest in narrative in art—in both religious and secular texts. For artists the task was to find ways of representing narrative on a vertical page, and of avoiding any ambiguity over the sequence of a story. They segmented pages, using medallions and roundels, or placed small scenes into separate frames.

Artists also had new illustrative material to work with in the secular texts: histories and romances, which were popular among the educated and wealthy nobility; and professional texts, for instance medical and legal. Some of the most delightful—and instructive for us—daily scenes of medieval life can be seen in these manuscripts.

Bibles moralisees, created for royalty in the mid-13th century, had a didactic and moralizing purpose. The page layout was usually eight circular medallions per page, with vertical text, the biblical passages being balanced with moralizing texts. This illumination is from one of the earliest, c.1240. The overall effect recalls stained glass windows of Gothic cathedrals.

A detail from the early 14th century Gorleston psalter, from East Anglia, showing a typically amusing scene.

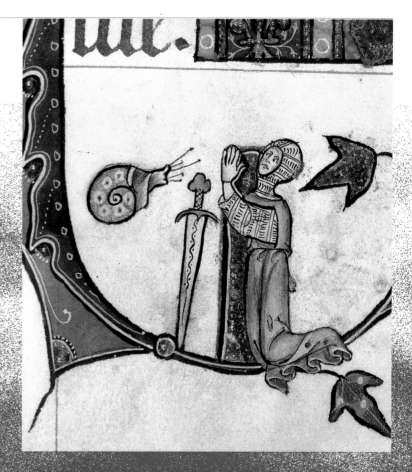

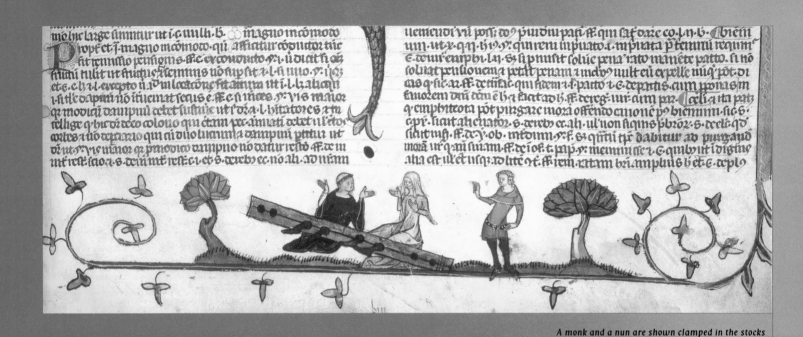

SOME ENIGMATIC IMAGES

Throughout much of the medieval period we find images in the *bas de page* of religious manuscripts that are a puzzle, for they seem to bear no relationship to the text itself. These often bawdy, impious, and fantastical images had their heyday from the 12th to 14th centuries, particularly in English and Flemish manuscripts. These were times of great social and economic upheaval. The Church was increasing in power and wealth, which provoked a great deal of criticism. Following the example of the Franciscans and Dominicans, many churchmen were filling their sermons with moral lessons, and often using legends, folktales, and animal images. The universities were creating an international, well-read and questioning population; and the new merchant middle class was upsetting the economic and social traditions of a previously feudal society.

The famous late 12th century *Carmina Burana* contained hundreds of what are essentially student songs, full of youthful drinking, gambling, and wenching, and of satirical verses on the ways of the adult world. The

tum nostrum

Recordatus est quoniam puluis
sumus: homo sicut fenum dies eius
tanquam flos agri sic efflorebit.

Quoniam spiritus pertransibit in
illo ꝓ non subsistet: ꝓ non cognoscet
amplius locum suum

Misericordia autem domini ab eter
no: ꝓ usque in eternum super timen
tes eum

Et iusticia illius in filios filiorū:
his qui seruant testamentum eius.

Et memores sunt mandatorum

growing vernacular literature was also satirizing and parodying human behavior and foibles: uncritical patronage, flattery, courtly behavior, the commercialization of everything, and general corruption.

The route was thus wide open to images—in the *bas de page*—which acted as visual annotations. So, we see donkeys playing lyres, monkeys delivering sermons, dogs jousting, a monk and lady sitting in stocks, knights fighting snails, apes interrupting scribes, and so on. To the contemporary reader, many of these animals, and birds in particular, had other meanings. The goat and the owl were associated with lechery and paganism respectively. Apes parodied people.

The Roman author Pliny, widely read and enjoyed throughout the Middle Ages, described in his *Natural History* 14 monstrous races at the edge of the world, where dwell "... blemyae and cynocephali—men with heads in their bodies and eyes on their chests," and of the gryllus, a face set on two legs. Such fantastical apparitions might have been the devil in one of his many disguises, for a Latin poem of the times, *Ysengrimus*, describes "... a devil whose beak is that of a hawk, whose mane is horse-like, with the tail of a cat, the horns of an ox, and the beard of a goat. Wool covers his loins, and his back is feathered like a goose. He has feet of a cock in front and those of a dog at the rear." Such texts provoked the artists' imagination.

We do not fully understand the meaning and relevance of the images, but since similar ones appear in stone sculptures and wood misericords in churches, they must have been understood by people of the times (rather like contemporary cartoons today).

But not all images in the *bas de page* were satirical. Many of them reflected in some way the message of the main miniature, or were there for purely decorative purposes, as for example the hunting scene in the *bas de page* of the Queen Mary Psalter (see page 77).

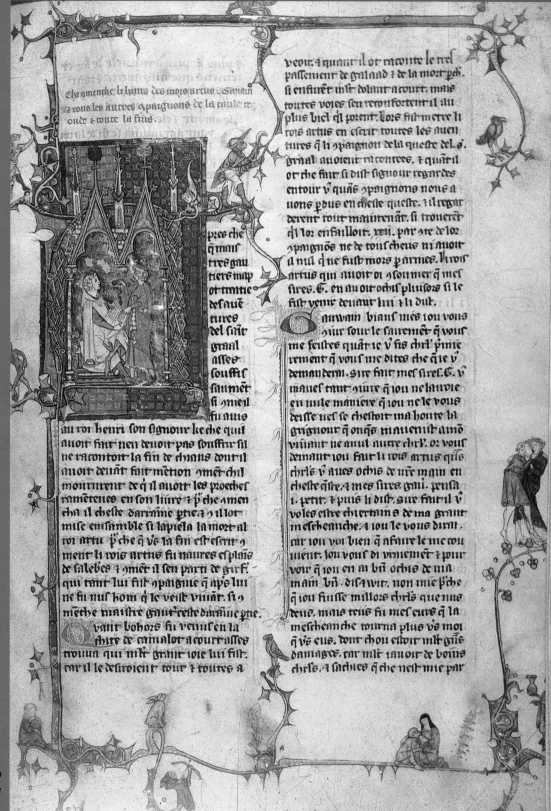

The initial on this page shows the scribe Walter Map taking down a story of the Knights of the Round Table on the quest of the Holy Grail, dictated by King Arthur.

5 HIGHLIGHTS 1350–1500

THERE WAS A HIATUS IN MANUSCRIPT PRODUCTION DURING THE PLAGUE YEARS OF THE MID-14TH CENTURY, WHEN IT IS ESTIMATED THAT A THIRD OF THE POPULATION OF EUROPE DIED, AMONG THEM MANY ARTISTS, SCRIBES, AND PATRONS. BY THE END OF THE 14TH CENTURY, ENGLAND WAS NO LONGER A PROLIFIC AND CREATIVE CENTER. FRENCH ARTISTS CONTINUED TO PRODUCE RICHLY DECORATED MANUSCRIPTS FOR ROYAL AND NOBLE PATRONS, OF WHICH THE BEDFORD HOURS IS A TYPICAL EXAMPLE, WITH ITS STRONG COLORS AND COMPLEX AND DETAILED VISUAL IMAGES. THE COURT OF BURGUNDY, UNDER THE PATRONAGE OF ITS CULTURED DUKES, AND THE WEALTHY TRADING CITIES OF FLANDERS (ACQUIRED BY THEM THROUGH MARRIAGE), WITH THEIR RICH MERCHANT COMMUNITIES, BECAME A THRIVING CENTER FOR THE ARTS AND PRODUCED SOME OF THE MOST OUTSTANDING MANUSCRIPTS OF THE PERIOD. AND THE DUKE OF BERRI, NOTED FOR HIS WONDERFUL LIBRARY OF SOME 300 MANUSCRIPTS, EMPLOYED FLEMISH ARTISTS TO CREATE MANY OUTSTANDING WORKS.

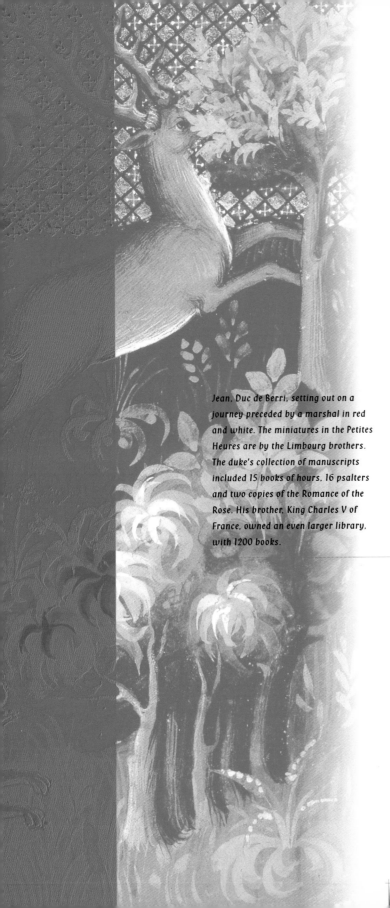

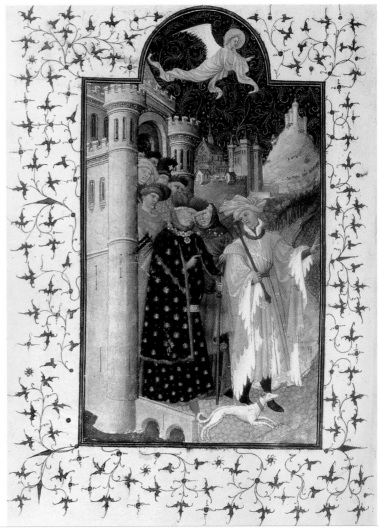

Jean, Duc de Berri, setting out on a journey preceded by a marshal in red and white. The miniatures in the Petites Heures are by the Limbourg brothers. The duke's collection of manuscripts included 15 books of hours, 16 psalters and two copies of the Romance of the Rose. His brother, King Charles V of France, owned an even larger library, with 1200 books.

Italy was the other major center where, by the middle of the 15th century, large numbers of lavish manuscripts were being produced. The patrons were the rulers of the north Italian courts of Urbino, Ferrara, Mantua, and Milan, the entourage of the Popes in Rome, but also the rich merchants and bankers of Tuscany, who boasted both wealth and education. For them books were increasingly objects to be studied and enjoyed in private, in the company of friends and other erudite readers, and they employed the most famous artists of the period to decorate their manuscripts. These patrons were also collectors of manuscripts, which meant that the book trade began to develop, and patronage, although important, was by the end of the 15th century playing a less important role in the production of manuscripts.

The layout and visual appearance of manuscripts produced in northern Europe and Italy differed considerably. Yet there were common elements. One was an increasing realism and use of perspective, originating with 15th century Italian panel and fresco painters. In these, contemporary people, dressed in styles of the day, relate to one another naturally in realistic interiors and landscapes.

In northern manuscripts this realism led to miniatures becoming important elements in a manuscript, increasingly separate from the text. This became aesthetically necessary, for 3-dimensional illusionistic illustrations sat uncomfortably around two-dimensional text. The increasing literacy throughout Europe meant that visual prompts—such as the variety of initials—were also less necessary. Borders around the text and miniatures became more framelike and were highly decorated. In the second half of the 15th century, borders in Flemish manuscripts were distinguished by *trompe l'oeil* flowers, birds and insects which are so lifelike they seem ready to be picked up and handled!

This Flemish manuscript, the Hastings Hours from Bruges or Ghent c.1480, shows the border style of the period. The subject is The Annunciation, stunningly decorated with life-like flowers and butterflies.

A mid-15th century copy of Pliny's Natural History, painted by Giuliano Amadei. The borders contain the typical white vine-stem interlace, and the text is written in the Humanistic Roman script.

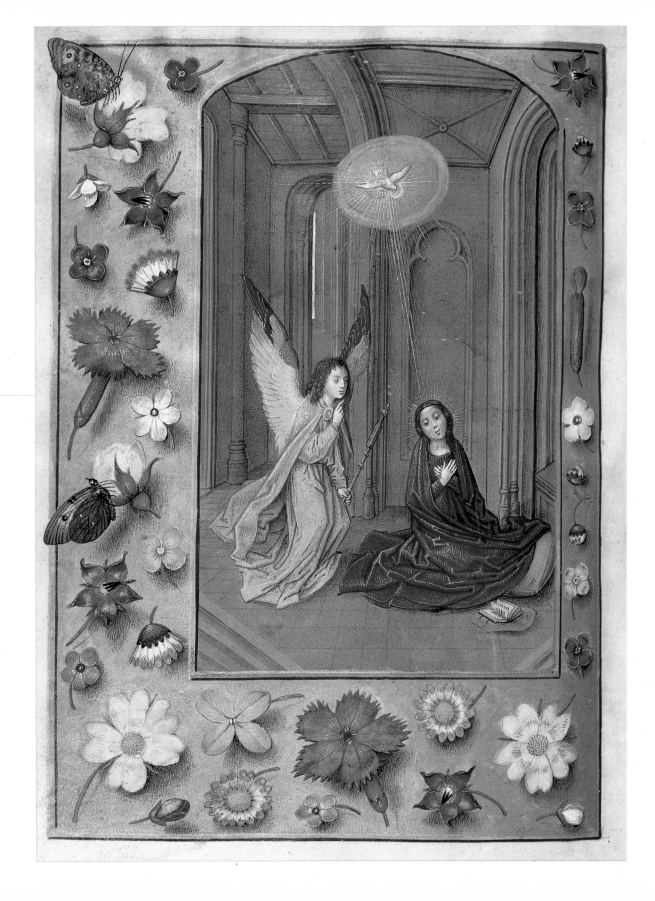

woir les cheuaulx tles fane
woutter et les frotter et aplier de
trestout quant quil pourra luy
z son varlet come est de bone litiere.

la viande. pour ce q
fait son deuoir.

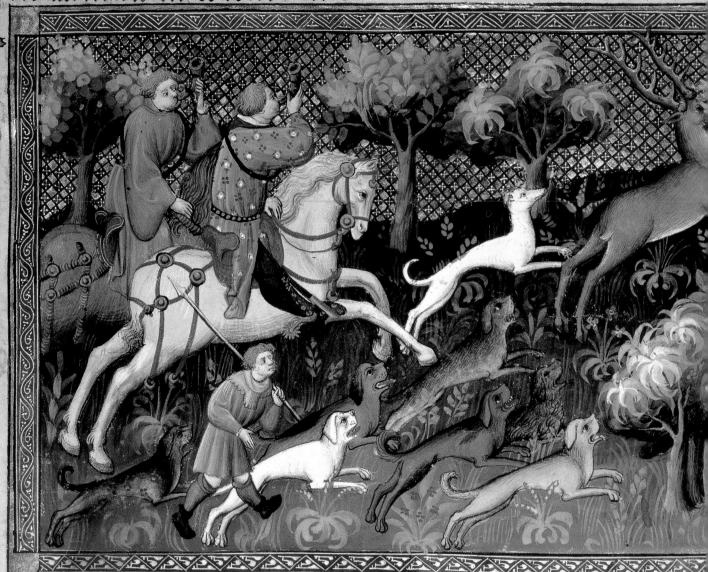

Cy deuaps deuise coment le lomene doit chalaer z prendre le cerf

In Italian manuscripts the text remained the dominant element on a page, and the decorative elements framed it. The Humanists—scholars and educated people who were rediscovering the importance and relevance of Antique philosophical, republican, and literary texts for their own lives and times—also influenced the illustrative material, which became increasingly Antique in style and content. Borders typically were filled with a white vine-stem interlace (which they believed to be of classical origin but was in fact 12th century Tuscan). From this interlace emerged birds and animals, as well as such classical images as putti and centaurs, garlands and vases. Architectural elements are recognizably of the Italian Renaissance, and the colors are generally softer than those in the northern manuscripts.

Another great center of manuscript production in the early years of the 15th century was the court of the Holy Roman Emperors in Prague. Wenceslaus IV, son of Emperor Charles IV, inherited his father's artistic interests, and commissioned some outstanding books. Bohemian artists had developed a style which owed much to Italian and French illuminations of the time, yet with distinguishing features.

Manuscripts of contemporary literature remained a favorite throughout Europe, with the writings of Dante, Petrarch, and Boccaccio in constant demand. At the same time romances continued to be popular, as did new treatises on such matters as courteous behavior, virtues and vices (medieval society, still full of a sense of guilt and sin, was fond of allegorical texts), and the ever-popular noble pastime of hunting.

The coming of printing in the 1450s spelled the end of manuscripts, but not immediately, and certainly not until the 16th century. Instead, it enhanced their value, simply because they were the original work of scribes and artists. Federico da Montefeltro apparently even refused to have any printed books in his library! In fact the printers of these first printed books aimed to recreate as closely as possible the beauty of the handmade books. Many of the earliest printed books continued to be illustrated by hand, and it is often difficult to distinguish an early printed book (or incunabula) from a manuscript.

One of the best-selling manuscripts of the 13th century was the Romance of the Rose. Written in France over a period of some 40 years, it featured wonderful images of medieval life.

From Pliny the Elder's Natural History, printed in 1476 by the Venice-based printer Nicolaus Jenson, illustrated with illuminations by Gherardo and Monte di Giovanni di Miniato.

From Gaston Phoebus' celebrated Livre de la Chasse, a treatise on hunting written in the 1380s and '90s, but not illustrated until 20 years later. Here we see a graphic picture of stag hunting with a background of embossed gold.

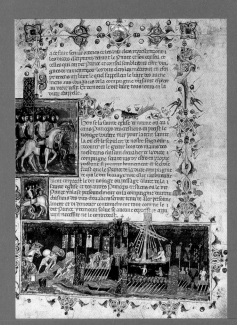

A French manuscript with illuminations depicting Crusaders departing by ship for the Holy Land.

Craftsmen engaged in the building of a cathedral, by the artist Jean Fouquet, from a French 15th century manuscript of the Jewish historian Josephus.

EVERYDAY LIFE

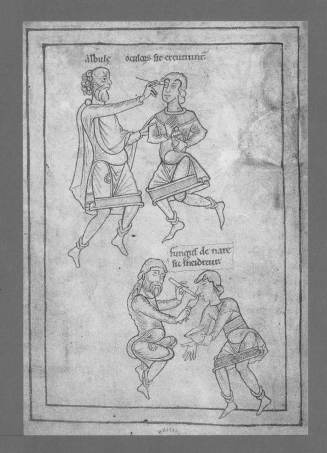

Manuscripts are the richest source of visual information we have about everyday life in the Middle Ages. Many of the miniatures and scenes in the *bas de page* place people in a contemporary setting. Although we need to make some allowances for fantasies or symbolic representations, illuminations in both religious and secular texts show us palaces and noble houses, details of architecture, contemporary fashions in clothing, craftsmen plying their trades, men and women practicing their professions, the peasantry at work, and the nobility amusing themselves.

There continues to be endless fascination in turning over the pages of illuminations and seeing the unusual, or spotting the still-familiar.

Physicians performing eye and nose operations, from a 12th century medical treatise written in Latin.

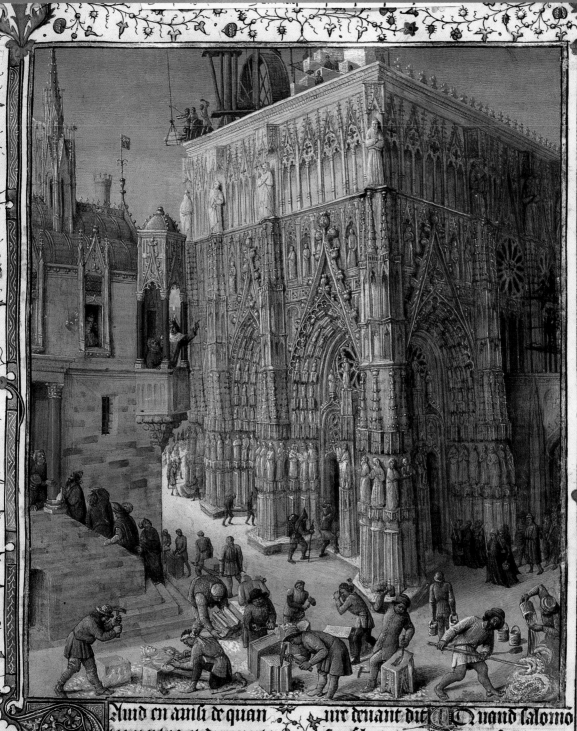

Auid en ainsi de quan
tes uertus et de quantz
biens il a este aucteur
a ceulx de sa liguee. et
combien plain de grant aige il est

nre deuant dit Quand salomo
son fil: auores icune enfant eut
prins le ropaume de son pic. et fa
assis ou siege ropal. tout le peuple
solennelment saueur. comme on

ACKNOWLEDGMENTS

AKG London /Orsi Battaglini/Museo di San Marco, Florence (Missale 558 f.24v) 48 /Bayerische Staatsbibliothek (Cod. lat. 4453 f.24r) 65, 65 tracing, Biblioteca Monasterio del Escorial, Madrid (Cod. Vitrinas 17 f.3r) 64 top /Bibliothèque Nationale de France, Paris (Ms fr.861 f.33v) 19 centre, (Ms fr.118 f.219v) 22 right, 23, (Ms lat. 10483-10484 f.24) 78 /British Library, London (Add. Ms 18850 f.12) 14 /Domschatzkammer, Aachen (Aachen Gospels f.14v) 60 bottom /Herzog August Bibliothek, Wolfenbüttel (Ms Guelph 105 Noviss 2' f.171v) 76 /Erich Lessing/Bibliothèque Nationale de France 91 inset, 91 background /Erich Lessing /Zisterzienserstift, Wilhering (Cod.CW 9 f.5r) 38 left, 38 right, 39 left, 39 right /Pierpont Morgan Library, New York (Ms M.240 f.8) 46

Bodleian Library Oxford (Douce 310) 93 bottom, (Ms Canon Ital. 85 f.114v) 22 bottom left

Bridgeman Art Library /Aberdeen University Library (Ms 24 f.5) 20, 20 background, 21 /Bibliothèque Municipale, Besançon (Ms 54 f.1) 2–3 /Bibliothèque Nationale de France, Paris (Ms fr.2645 f.321v) 12–13, 14–15, (Ms lat. 10525) 15, (Ms nouv. acq. lat. 1673 f.41) 22 top left, (Ms nouv. acq. lat.1203 f.3v-4) 61, (Ms fr.616 f.77) 86–87, 88–89, 92, (Ms fr. 4276 f.6) 94 top, (Ms fr.247 f.153v) 95 /Bibliothèque Sainte-Geneviève, Paris (Ms 2200 f.58) 24 inset, 24–25 /British Library, London (Ms Roy. 15 E III f.269) frontispiece, frontispiece tracing, (Add. Ms 22557 f.9v) 4, (Ms Yates Thompson 8 f.294) 6, (Ms Roy. E V f.5) 8–9, (Add. Ms 33241 f.1v) 10–11, (Add. Ms 47682 f.21v) 13, (Add. Ms 39943 f.26) 17, 17 tracing, (Ms Harley 4379 f.23v) 18, 19 left, 19 right, (Add. Ms 18850 f.257v) 53, (Ms Harley 4431 f.3) 54–55,(Ms Cotton Claud. B IV f.38) 56–57, 58–59, (Ms Cotton Nero D IV f.139) 59, (Ms Stowe 944 f.6) 60 top, (Add. Ms 10546 f.29r) 62, 62–63, (Add. Ms 49598 f.45v) 64 bottom, (Ms Eg.3781 f.1) 67, (Ms Eg. 3127 f.1v) 68, (Ms Cotton Nero C IV f.39) 75, (Ms Roy. 2 B VII f.151r) 77, (Ms Harley 1527 f.27) 80, (Add. Ms 49622 f.162v) 81, 81 tracing, (Ms Roy. 10 E IV f.187) 82, (Add. Ms 42130 f.181v) 83, (Add. Ms 54782 f.73v) 91, (Ms Harley 4425 f.14v) 93 top, (Ms Harley 1585 f.9v) 94 bottom /Fitzwilliam Museum, University of Cambridge (Ms 83–1972) 37 /Giraudon/Biblioteca Piccolomini, Siena Cathedral 16 bottom /Giraudon/Bibliothèque Municipale, Dijon (Ms 173 f.92v) 26–27, 28–29, 44, /Giraudon/Bibliothèque Nationale de France, Paris (Ms fr. 1584 f.1) endpapers, (Ms 9198 f.19) 32 tracing, 32–33, (Ms lat. 8846) 40–41, (Ms lat. 18014 f.288v) 89 /Index/Archivo Capitular de Osma, Soria (Ms 126-0035141 sheet 7) 34–35, 34, 44–45, 45, /Index/Biblioteca Monasterio del Escorial, Madrid (Ms 131–0794738/1) 78–79 /Kungl. Biblioteket, Stockholm (Ms A 135 f.11r) 30, 30 –31 /Lambeth Palace Library, London (Ms 69 f.55) 35, 42–43, 42, (Ms 368 f.66) 70–71, 72–73, (Ms 3 f.6) 74 /Master and Fellows, Magdalene College, Cambridge (Pepysian Library Ms 1916 f.13r) 36 /Museo Civico, Turin (Ms 47 f.93v) 49, 49 tracing, /Pierpont Morgan Library, New York (Ms M.644 f.87) 7 /John Rylands University Library, Manchester (Ms Fr. 1 vol.1 f.82r) 85 /Trinity College, Cambridge (Ms R16.2 f.14v) 16 top, (Ms R.17.1 f.283v) 31, /Winchester Cathedral, Hampshire 66

Dean and Chapter Library, Durham (Ms A II 4 f.65) 47

E.T. Archive /Biblioteca Estense, Modena (VG. 12 (Lat) 422) 52 top, 52 bottom

Reed International Books Ltd. /St Godehard, Hildesheim (Albani Psalter f.19r) 73

Universiteitsbibliotheek Utrecht (Ms 32 (Script. Eccls. 484) f.17r) 63

V&A Picture Library (567–1893) 51, (AL. 1504–1896) 90